D1309667

Realistic Collage
STEP BY STEP

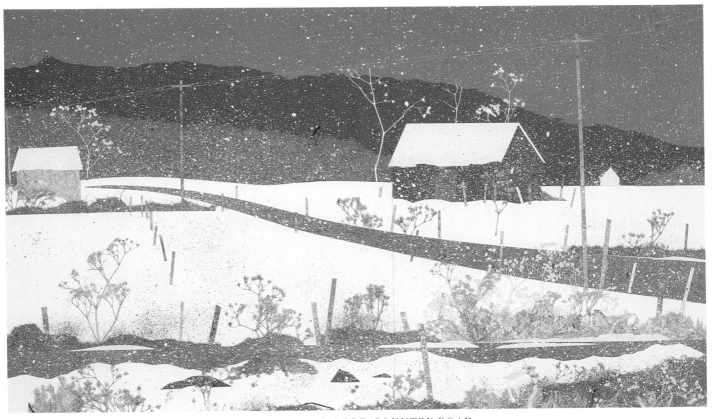

SNOWY DAY ON OLD COUNTRY ROAD
11½" × 17½" (29.2cm × 44.5cm)

MICHAEL DAVID BROWN & PHIL METZGER

NORTH LIGHT BOOKS
CINCINNATI, OHIO

Realistic Collage Step by Step. Copyright © 1998 by Michael David Brown and Phil Metzger. Manufactured in China. All rights reserved. No part of this book may be reproduced in any form or by any electronic or mechanical means including information storage and retrieval systems without permission in writing from the publisher, except by a reviewer, who may quote brief passages in a review. Published by North Light Books, an imprint of F&W Publications, Inc., 1507 Dana Avenue, Cincinnati, Ohio 45207. (800) 289-0963. First edition.

This hardcover edition of *Realistic Collage Step By Step* features a "self-jacket" that eliminates the need for a separate dust jacket. It provides sturdy protection for your book while it saves paper, trees and energy.

Other fine North Light Books are available from your local bookstore or direct from the publisher.

02 01 00 99 98 5 4 3 2 1

Library of Congress Cataloging-in-Publication Data

Brown, Michael David.
 Realistic collage step by step / Michael David Brown & Phil Metzger.—1st ed.
 p. cm.
 Includes bibliographical reference and index.
 ISBN 0-89134-819-0 (hardcover)
 1. Collage—Technique. I. Metzger, Philip W. II. Title
N7433.7.B79 1998
702'.8'12—dc21 97-35158
 CIP

Edited by Glenn Marcum and Joyce Dolan
Production edited by Saundra Hesse
Designed by Brian Roeth

The permissions on page 125 constitute an extension of this copyright page.

ABOUT THE AUTHORS

Michael David Brown

Trained at the University of Northern Colorado and the Colorado Institute of Art, Michael Brown established a graphic design and illustration firm in Maryland in 1973. After a long career of commercial illustration he shifted gears to fine art collage. His works have garnered gold and silver medals from juried professional graphics shows—such as Communication Arts, Graphis, Society of Illustrators, American Institute of Graphic Arts and the New York and Metropolitan Washington Art Directors Club Shows—and received worldwide attention at exhibits in Brazil, South Korea, Japan, France, Finland and Poland. He has undertaken assignments ranging from multivolume book series for the Smithsonian Institution and National Geographic Society; books and magazines for government agencies, publishers and trade or educational associations; corporate literature for many Fortune 500 firms; as well as a steady flow of promotions and posters for Arena Stage, the Washington Opera and other cultural groups.

Michael Brown also lectures at professional meetings and university classes throughout the U.S. and has served as an adjunct professor at The Maryland Institute, College of Art, in Baltimore.

Besides drawing and painting, Michael Brown admits to a passion for travel and collecting American antiques. He makes his home in Rockport, Maine with his wife, Carol, and infamous bassett, Molly. His son, Ian, carries on the tradition as a fine arts student.

Phil Metzger

Without benefit of any formal art training, Phil Metzger left a fifteen-year career in computer programming and management to become a painter. For twenty years he has exhibited his paintings in national and regional shows and has sold his work occasionally through galleries, but mostly at street art fairs. During that time he developed a parallel interest in writing. Having made a number of firm decisions to do one or the other—paint or write—he has now made a firm decision to do both.

Metzger's books include *Perspective Without Pain* (North Light, 1992), *Enliven Your Paintings With Light* (North Light, 1994) and *The North Light Artist's Guide to Materials & Techniques* (North Light, 1996). He has also written articles on drawing for *The Artist's Magazine* and *Arts and Activities* magazine.

To my wife, Carol, and son, Ian, my constant source of pride and inspiration, and to Phil Metzger, my longtime friend, whose writing skills and guidance made this book possible.

MICHAEL DAVID BROWN

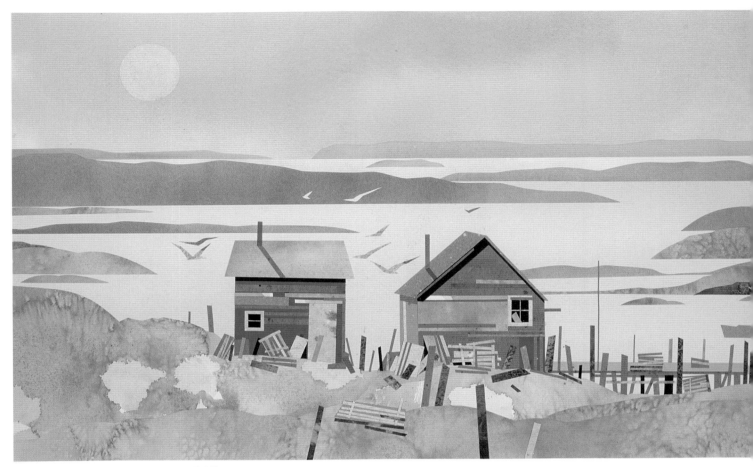

ON THE ROAD TO SPRUCE HEAD
13" × 21½" (33cm × 54.6cm)

ACKNOWLEDGMENTS

Pictures and words don't make a book. There's a lot of work by people other than the authors. Michael Brown's wife, Carol, for example, is the organizer in the family. She files and proofreads and keeps Michael doing what he does best, which is painting. And Phil's buddy, Shirley Porter, always adds her more-than-two-cents and gets involved in each book Phil writes. We thank Carol and Shirley for their hard work and their forbearance.

Then there are the people at North Light, who always do a super job of transforming a manuscript into a real book. (When an author turns in a manuscript, he thinks it's perfect. Ha!) From the acquisition editor, Rachel Wolf, who saw merit in the proposal for this book, to Saundra Hesse, who handled all aspects of getting the book through production, everybody did a great job. In between Rachel and Saundra were editors Joyce Dolan and Glenn Marcum. Joyce steered the project from its early days, giving us the guidance we needed; and Glenn did a superb job of content editing. All these people, along with Brian Roeth, an excellent book designer, turned our mush into a beautiful product. We thank them all.

We also thank artists Peggy Brown, William and LaTrece Coombs, Bob Kilvert, Nita Leland and Virginia Lee Williams for contributing art that beautifully complements Michael Brown's work. And thanks to photographer Fred Kaplan for his help and advice on photographing the art and materials you see in the book.

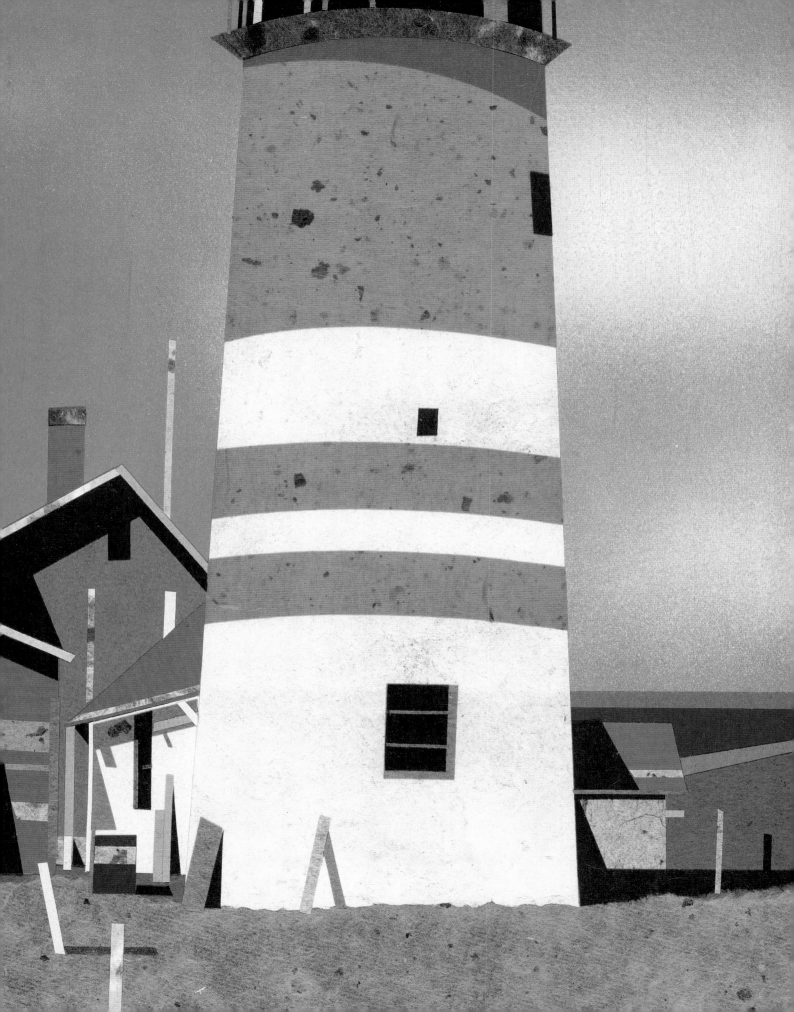

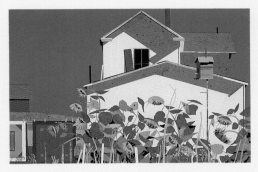

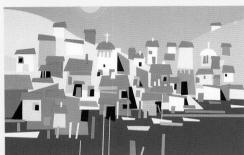

TABLE OF CONTENTS

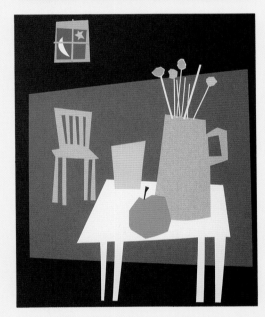

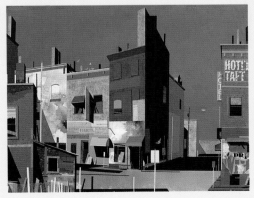

LAND'S END
8″ × 10½″ (20.3cm × 26.7cm)

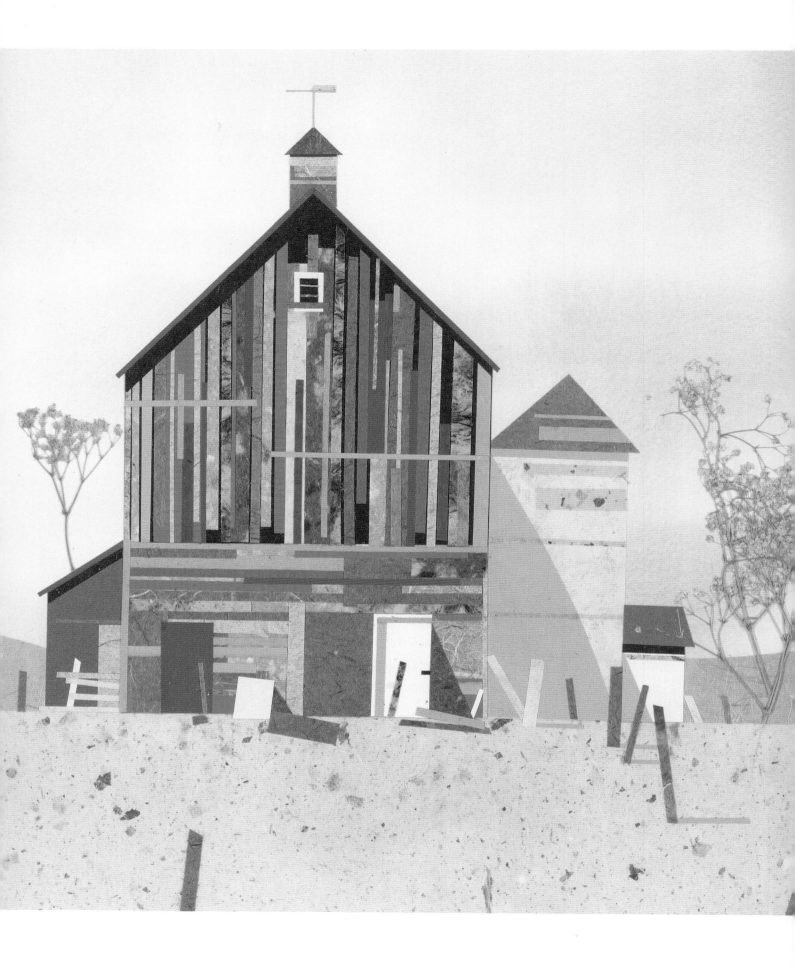

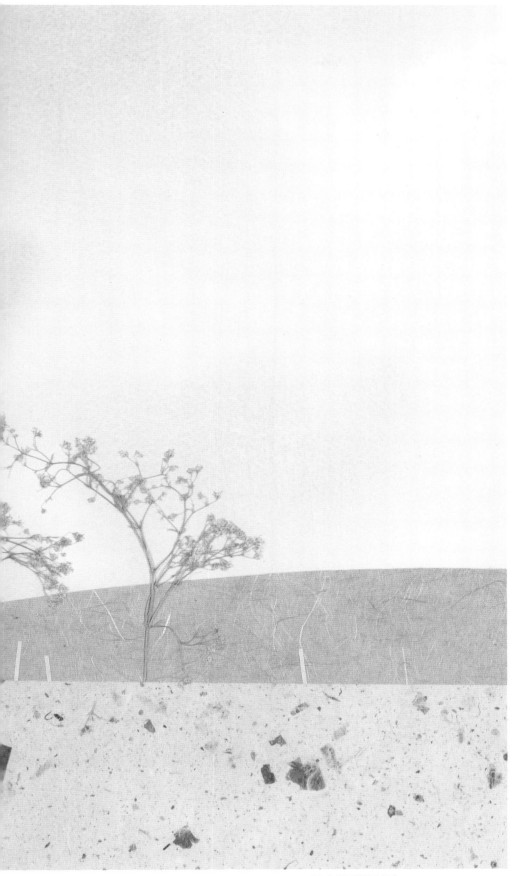

INTRODUCTION

A collage is a picture made by gluing materials to a surface. While the most common materials are papers, anything may be used. The surface of a finished collage may be smooth (as are many of Michael Brown's works) or exceedingly rough. Rougher, lumpier collages often involve fastening down heavy materials, such as pieces of wood or metal, and sometimes pieces are held in place by something stronger than glue—wire, threads or screws, for example. Such heavier, more three-dimensional pieces are often called *assemblages* rather than *collages*. In this book we'll deal mostly with traditional collages made from relatively flat materials, such as papers, fabrics, screens, and so on.

Art history is full of art forms originally considered nonserious. Watercolor is an example, but as everyone knows, watercolor is now accepted as a serious medium. Collage art has had a similar history.

Part of the reason that collage was once taken less seriously than other art forms is the playful nature of the process—you cut, paste and make as much mess as a child in kindergarten. But while collaging surely does allow for playing and enjoying the process, the result can be as satisfying as any painting. You need only look at the works of Michael Brown and others to see that collage art is serious and exciting and satisfying and here to stay.

FALLOW FIELDS
16"×21" (40.6cm×53.3cm)

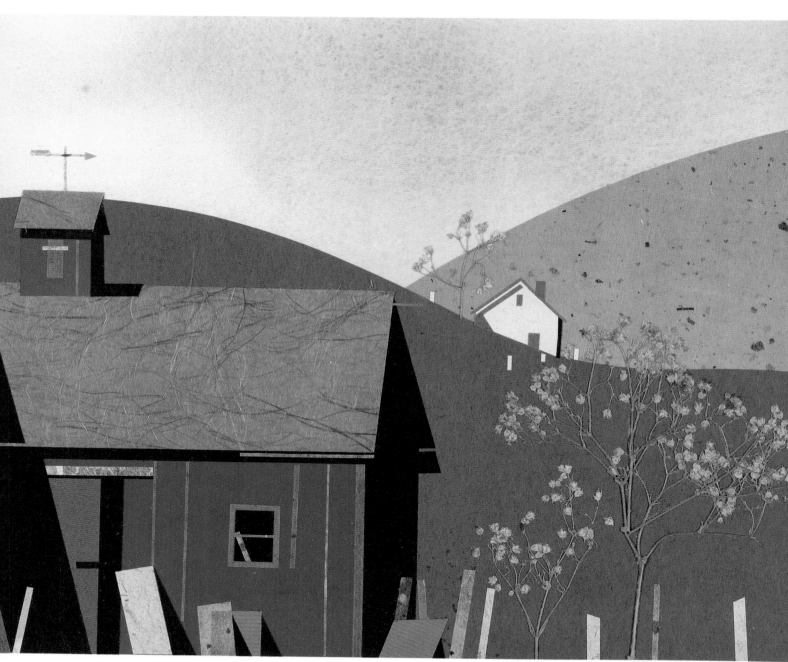

BARN ON MILLER ROAD
8½″×11″ (21.6cm×27.9cm)

chapter one
Collage Tools and Materials

The tools and materials you need to begin collaging are simple and inexpensive. Once you're hooked on collage, you may graduate to more exotic (and expensive) papers and fabrics, but your tools will still be simple and cheap. The only exception is the cost of a dry-mount press, if you decide to go that way.

A Basic Shopping List

If you are a painter you may have in your studio everything you need to make a collage. But if you're a beginner, here is a list of materials and tools that will get you started:

- A sharp knife, such as a craft knife, a utility knife or even a single-edged razor blade.
- A sharp pair of scissors.
- A straightedge. A plastic triangle is handy, but a ruler is also fine. If the ruler is lightweight, glue a strip of fine sandpaper to its bottom surface to keep it from shifting while you cut alongside it.
- A jar of acrylic gel medium.
- A brush for applying the acrylic medium. A ¾-inch (1.9cm) synthetic-bristle brush would be appropriate.
- Clean papers, such as newspapers, on which you can lay a piece of collage paper while brushing its back surface with acrylic medium. Change papers often so you don't lay a piece of collage paper into sticky medium left from the last brushing.
- A plastic bowl of water for cleaning the brush—if you let acrylic medium dry in the brush, it will ruin the brush.
- Paper towels for general cleanup.
- A working surface you can cut on without damaging your furniture.
- Illustration board, watercolor board or mat board for the collage support.
- Drafting tape for marking off the edges of the support. When you remove the tape, you have a nice clean border surrounding your collage.
- A set of colored construction papers. You can find them in art stores and larger toy stores. These are the papers kids use for school projects. They are not fade-resistant, but they serve well as learning materials.
- Anything else around the house you can glue down and make part of your collage.

Supports

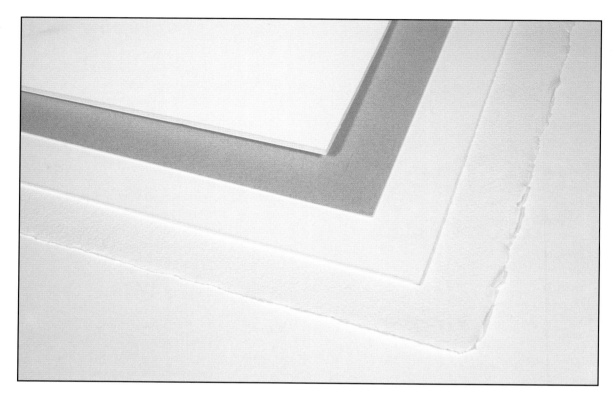

Supports
Common supports, or backing, for collages (from the bottom): heavy watercolor paper, illustration board, mat board, foamboard.

The support, or backing, is the base for your collage—the surface to which everything is glued. The most common supports are watercolor boards, illustration boards, mat boards, foamboards and watercolor papers. You may also use stiffer materials, such as wood and hardboard, but they'll add a lot of weight to your finished piece.

WATERCOLOR BOARD AND ILLUSTRATION BOARD

These are pieces of cardboard with watercolor or drawing paper factory-glued to their surfaces. The cardboard provides stiffness, and the paper is the surface on which you normally paint or draw or, in our case, build a collage. Because they are reasonably lightweight yet rigid, these boards are good candidates for collage supports. They have the added advantage of being excellent painting surfaces, should you decide to paint the background for your collage. As for per-

SUPPORT	PRO	CON
watercolor board or illustration board	stiff, lightweight, good painting surface	heavier than watercolor paper
300-lb. (640g/m²) watercolor paper	good painting surface	will warp some
mat board	many colors available, flexible	will warp some
foamboard	lightweight	can crack
wood	stiff, strong	heavy, acidic
hardboard	stiff, strong	heavy, acidic

Whichever material you choose for a support, make sure it's acid-free and, if its color will show through in your collage, choose permanent colors.

SOME POPULAR COLLAGE SUPPORTS WITH ACID-FREE SURFACES

Arches 300-lb. (640g/m²) Watercolor Paper	Rough, cold-press, hot-press surfaces
Fabriano Artistico 300-lb. (640g/m²) Watercolor Paper	Rough, cold-press, hot-press surfaces
Lanaquarelle 300-lb. (640g/m²) Watercolor Paper	Rough, cold-press, hot-press surfaces
Crescent Watercolor Board, #112, 114, 115	Cardboard core not acid-free
Crescent No.1 Cold-Press Illustration Board	Cardboard core not acid-free
Crescent Premium Watercolor Board, #5112, 5115, 5117	Acid-free core
Strathmore 500-Series Illustration Board	High-quality white core, but not acid-free
Crescent Rag Mat Museum Board	Acid-free rag core and backing; wide variety of colors that are "fade resistant"
Rising Museum Board	Acid-free throughout; six pale colors
Bainbridge Alphamat	Acid-free throughout, wide variety of colors that are "fade resistant"

manence, there are many boards with acid-free surfaces and a few whose cardboard cores are acid-free as well.

Watercolor boards come in a variety of thicknesses. For a large collage you may want to use a thicker board, but keep in mind that with thickness comes more weight. By the time you build a collage and add glass, mat and frame, you may be dealing with a few pounds more than you anticipated.

WATERCOLOR PAPER
Michael Brown sometimes uses a heavyweight watercolor paper for his supports. A paper such as 300-lb. (640g/m²) Arches is lighter than boards but stiff enough to support his collage. The only drawback when using paper is that you'll get some warping as you paste things down. However, you can easily flatten things when it comes time to mat and frame your work.

MAT BOARD
Thinner than most watercolor and illustration boards, mat board (the same material you use to surround your finished work when it's ready to frame) is a satisfactory surface to work on. However, like watercolor paper, it will warp a little. A real advantage in using mat board is that it's available in a great variety of colors. If you're interested in permanence (as you should be), choose mat boards that are acid-free and colorfast (see page 20).

FOAMBOARD
This material is commonly used as backing when framing watercolors and other paintings or drawings. It's lightweight and stiff and is commonly available in ⅛″ (.3cm) and ³⁄₁₆″ (.5cm) thicknesses. You can buy the acid-free variety for permanence. The only drawback is the board's inflexibility; it will crack if you bend it too far.

WOOD AND HARDBOARD
Unless you're building a heavy assemblage or want to support your chiropractor, don't use wood or hardboard as a support. By the time you add a few pounds of paper, glass and a frame, you may have a heavy critter on your hands. Wood and hardboard are acidic and should be coated with acrylic gesso to help seal off their acids from your artwork.

Collage Papers

You may use several kinds of paper to collage. When you choose papers for any artistic purpose, consider their permanence; choose those labeled either acid-free or pH-neutral. Many such papers are available, so there's little excuse for settling for acidic papers. When shopping the catalogs, if a paper is not listed as acid-free or pH-neutral, assume the worst and keep looking! (For more information on the permanence of your materials see page 20.) Most of Brown's work is done with papers. He keeps cabinet drawers stocked with papers of all kinds and colors and textures, and he often prowls stores and catalogs looking for new ones.

WATERCOLOR PAPERS

These come in many sizes and textures. So many are acid-free that you need never consider using those that aren't. Watercolor papers can be used in various ways:

• As a support, or backing, for your collage. Since the paper is intended for painting, it's a natural choice if you decide to paint your collage background. If you use watercolor paper as a support, choose one that is at least 300-lb. (640g/m²). Thinner papers are too flimsy to resist warping and curling as you build your collage. See pages 12-13 for more on supports.

• As pieces of the developing collage. You may either glue on pieces of unpainted white watercolor paper or you may paint the papers before or after gluing them down.

PASTEL AND DRAWING PAPERS

Pastel and drawing papers come in a wide range of colors. Those that are acid-free and reasonably colorfast (see accompanying table) are good collage candidates.

Pastel Papers
Pastel papers are made in a wide range of colors. Look for those that are labeled at least "fade-resistant."

SOME POPULAR ACID-FREE PASTEL PAPERS

BRAND	COLORS*
Canson Mi-Teintes	45
Fabriano Murillo	19
Fabriano Roma	8
Holbein Sabretooth	9
Larroque Bergerac	16
Sennelier La Carte	14
Strathmore Mil-Tinte	28

Each of these papers except Sabretooth has some rag content. They all come in a variety of sizes and thicknesses. Some are offered as single sheets, some in pads, some in rolls. All claim a high degree of lightfastness.

*The number of colors available varies from one catalog or store to another.

Sample Pack

Some stores and catalogs offer sample packs of papers for a reasonable price. Here are some exotic decorative papers from a sample pack offered by the Daniel Smith catalog. The pastel papers in the previous illustration are from another sample pack in that same catalog.

DECORATIVE AND EXOTIC PAPERS

This is a general category that includes rice papers; Mexican bark papers; papers from countries as diverse as China, Japan, Egypt, France and India. There are papers with embedded flecks and fibers, a variety of textures and a selection of beautiful colors. Many of these papers are acid-free, but few of them claim to be colorfast. Despite questions about color permanence, these papers are popular among collage artists.

CONSTRUCTION PAPERS

You're probably familiar with pads and sheets of construction papers that are used by children in schools. They come in a good variety of colors, but are usually neither acid-free nor colorfast.

NEWSPAPERS AND MAGAZINES

Many collages incorporate pieces of magazine and newspaper pages. Few of these are permanent, but some are a better bet than others. For example, the pages from *National Geographic* and similar expensive magazines are certainly made from better materials than newspapers and cheaper magazines. Newspapers and magazines are intended for relatively short lives; they're not made for collage artists, yet many collage artists find these materials irresistible. In the section on permanence, we'll discuss some things you can do to increase the life span of impermanent collage materials.

Papermaking

There are three ways of making papers:

Handmade papers are made one sheet at a time. Pulp (a mixture of water, chemicals and fibers, such as cotton or linen) is poured into a shallow box that consists of a wooden frame (called the *deckle*) with a wire mesh on the bottom. The fluids are allowed to drain out through the mesh, leaving behind a mat of damp fibers. When dry, the mat becomes a sheet of paper. Some pulp seeps under the wood frame, and when the frame is later removed, the result is an irregular (deckle) edge. The fibers in a handmade paper lie randomly throughout the paper.

Mouldmade once meant handmade but now refers to a refined machine process that simulates handmade results. These papers are made on a device called a Cylinder machine that allows the fibers to settle fairly randomly, as in the handmade process. Deckle edges are simulated.

Machine-made papers are made on a faster, more production-oriented machine (called a Fourdrinier). Fibers tend to align in one direction (the direction in which the assembly line belt of pulp is moving), so the texture of this paper is less random, more mechanical looking. If you tear a piece of this paper, it tends to tear in only one direction.

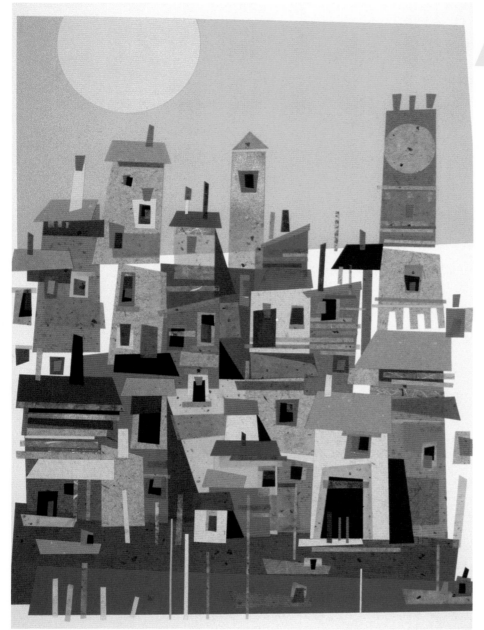

This colorful cluster of buildings at the edge of the water was built up in the same manner as the demonstration beginning on page 53, using a variety of flat-colored pastel papers and textured exotic papers. The orange sky was painted with acrylic paints.

HARBOR
20" × 16"
(50.8cm × 40.6cm)

How to Make Your Own Colored Papers

1. Choose acid-free white papers in a variety of weights and textures to suit your needs. Stretch the papers as you would in preparation for painting a watercolor—that is, soak the paper in water and then fasten it (while still wet) to a board with tape, clamps, staples or tacks.

2. Using diluted paint, paint the paper to get whatever effect you wish. You may paint an entire sheet in a single flat color, or you may grade the color or introduce other colors or materials such as salt or sand for textured effects. Use acrylic or watercolor paints, and choose only those rated as permanent. Make a variety of papers, some pale, some intensely colored, and so on.

3. Allow each sheet of paper to dry thoroughly before releasing it from the board and storing it. Some papers, such as watercolor papers, will dry flat; others may retain some wrinkles. As you store each piece of colored paper, keep a clear record of the paper you used and the exact colors you used. You'll end up with some lovely papers and will later wish you could remember just how you produced them!

When coloring your own papers, it's a good idea to set aside enough time to make lots of sheets at once. It's no fun to have to stop midway through a collage to make more papers.

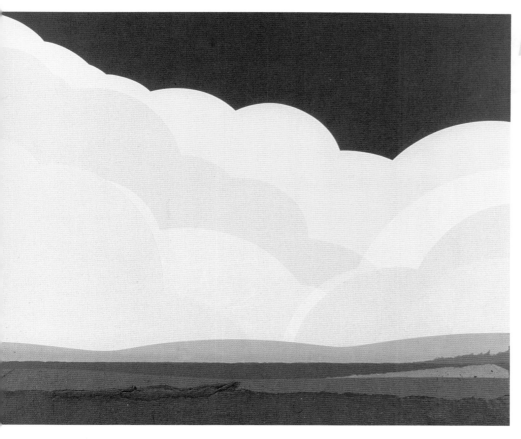

Rag Papers

Rag papers are made from fibers such as cotton and linen, rather than wood. Such papers have beautiful working surfaces, and they are tough and durable—with proper care, they will last for centuries. The most common rag paper is made from pieces of cotton cloth (rags) left over from the manufacture of T-shirts. While most rag papers are buffered so that they are acid-free, not all of them are. The best papers are those that are labeled "rag" and "acid-free."

COLORADO CLOUDS
30″ × 40″ (76.2cm × 101.6cm)

It's not always easy to make such large, simple shapes work. In this all-paper collage, Brown needed a series of papers for the clouds that were all light but close in value. The dark blue sky area makes the clouds stand out—if you cover the dark blue with some light-value color, you'll see that the picture loses its punch.

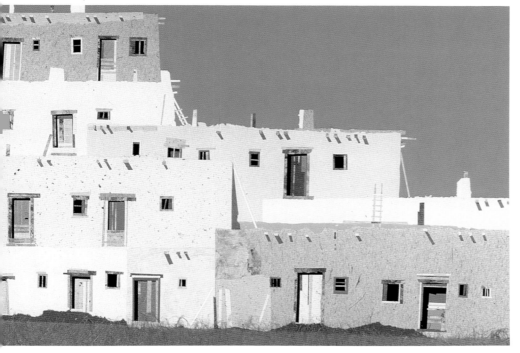

TAOS PUEBLO
30″ × 40″ (76.2cm × 101.6cm)

Brown spent some time in Taos, New Mexico, early in his collage career. He was fascinated by the colors of the Southwest and by the unique architecture. This pueblo immediately caught his eye. It had beautiful colors and textures and—something Brown looks for—very little symmetry. He prefers structures with odd combinations of shapes, a variety of sizes of windows and doors, and eye-catching details, such as the ladders and projecting beams shown here. This collage is all paper except the sky, which was painted with acrylics.

Nonpaper Materials

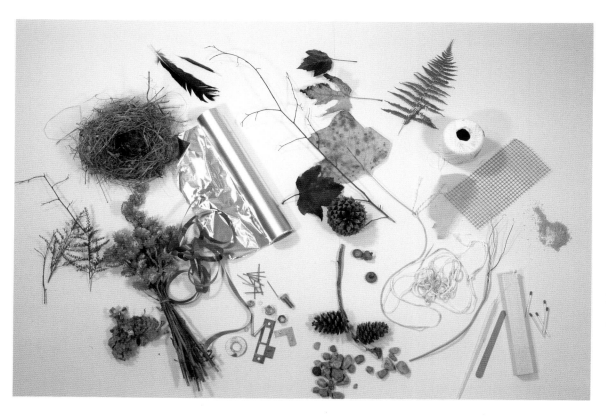

Use Anything and Everything
Collage artists often become pack rats. Almost any object is a candidate for inclusion in a collage, provided you can figure out a way of fastening it to the support. Acrylic adhesives will secure most things, but sometimes a piece must be bolted or screwed in place or tied down with thread or wire. The fasteners themselves become a part of the collage.

You may include in a collage anything you wish, including wire, glass, plastic, bark, string, stones, sand, leaves, weeds, fabrics—the list is truly endless. As in the case of papers, you need to consider the longevity of the items you choose.

As you gather objects, it's prudent to store them in a way that helps you find them when you need them. Tossing everything into a drawer is bound to cause frustration at picture-making time. Chests of labeled drawers, even if they must be kept in the garage or the attic, will save you a lot of search time.

PAINTS
Paints are often used in all or part of the background to set a mood for the collage. The best paints to use, either on the background or on pieces of the collage, are acrylics and watercolors. Both are compatible with adhesives, and both are available in many permanent colors.

Don't use oil paint; it's difficult to make collage pieces stick to an oil-paint surface. Avoid fragile paints (such as gouache) that might crack or flake off.

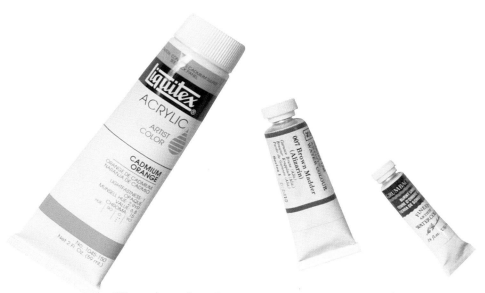

Watercolor and acrylic paints are suitable for use in collage work.

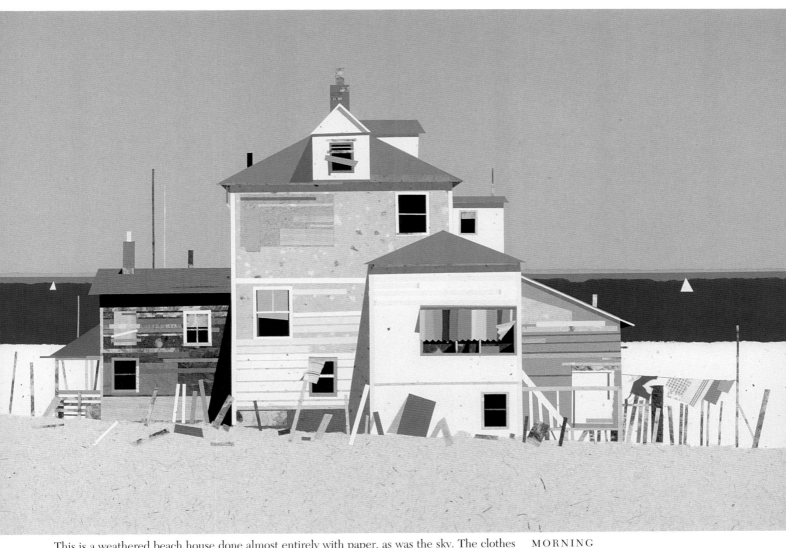

This is a weathered beach house done almost entirely with paper, as was the sky. The clothes on the line are bits of cloth, and the awning is pillowcase material contributed by Brown's wife, Carol. She also suggested the fibrous paper he used for the sandy foreground.

MORNING
30″ × 40″ (76.2cm × 101.6cm)

Permanence

Many materials that are attractive as parts of a collage are also impermanent. There are two aspects to permanence of materials: acidity and lightfastness.

A well-known artist told his class about a collage he had done using some lovely purple paper along with acrylic paint. He turned the collage over to a gallery where it was exhibited in a sunny window. A month later the artist was shocked to find his collage nearly unrecognizable. All that deep purple had turned to dull gray!

If you're serious about your work, you'll want it to last forever. You'll demand to know about the longevity of the materials you purchase, but you won't always get clear answers. Terms like "fairly permanent" and "fade-resistant" are better than nothing, but still leave you wondering. Over time, you can conduct your own tests and feel more secure about the materials you're using.

ACIDITY

Artists take pains to avoid using acidic materials in their artwork because acids tend to cause long-term damage, including weakening of fibers and yellowing or browning of surfaces. Newspaper is made from acidic wood pulp, and you know how quickly a newspaper disintegrates.

All materials are either acidic, alkaline or neutral. The unit of measurement for acidity/alkalinity is called *pH*, and it has a range of 1 to 14. A material that has a pH of 1 is highly acidic, a pH of 14 is

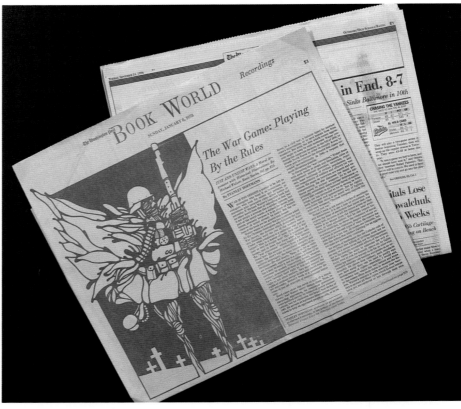

Newspapers Deteriorate
Newsprint, made from wood pulp, contains acids that cause rapid deterioration of the paper. The whiter newspaper here is only a few weeks old, while the yellowing one (with the Michael Brown illustration) is several years old. Had it not been stored in a drawer away from sunlight, it would by now be even yellower.

highly alkaline, and a pH of 7 is neutral. The ideal pH for art materials is 7 or a little higher.

In papermaking, alkaline substances called *buffers* are often added either to the pulp or the finished paper to neutralize any acids present. But pH-neutral paper may not remain that way. Exposure to acidic environments—polluted air or cheap mat board—can cause the paper to become acidic. For that reason, papermakers often add extra buffer to the paper as a hedge against future exposure.

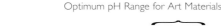

Not Only Paper

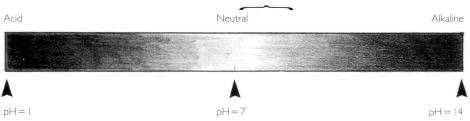

Paper is not the only collage material that may be acidic. Certainly tree bark and other organic materials, such as weeds and flowers and grasses, are suspect. Oil paint is also acidic. One of the ways you can minimize the harm acidity may do your collage is to isolate acidic materials with nonacidic coatings, such as acrylic medium or acrylic varnish, to help prevent acids from leaching out into other materials.

Optimum pH Range for Art Materials

Acid Neutral Alkaline

pH = 1 pH = 7 pH = 14

Lightfastness

Lightfastness is the ability of a color to resist (1) fading and (2) change of hue. When a color fades, it becomes a lighter version of that same color—for example, dark blue becomes light blue. When a color changes hue, it becomes an entirely different color—for example, purple may change to gray.

LIGHTFASTNESS OF PAPERS

Lightfastness is a tougher problem than acidity when buying papers. While lots of papers are acid-free, relatively few colored papers are lightfast—that is, free from the twin dangers of fading and changing color. Fading and color changing are due mostly to exposure to light—especially ultraviolet light, which is present in sunshine. There are several ways you can minimize fading and color change:

1. Look for papers that are listed as colorfast or, at least, fade resistant.
2. Varnish a finished collage using varnishes with ultraviolet (UV) inhibitors. They are not perfect, but they'll help.
3. Frame your collage under UV-inhibiting glass or Plexiglas. These products cost much more than plain glass or Plexiglas, but they do a good job of screening out ultraviolet light.
4. Hang collages (and other artwork) away from direct sunlight and, in general, in moderately lighted areas.
5. Color your own papers using permanent paints (see sidebar page 16).

LIGHTFASTNESS OF PAINTS

Choosing colorfast paints is no problem. Many hues in both acrylic and watercolor are rated as colorfast. Manufacturers use several different systems to designate the degree of permanence—that is, resistance to fading or color change—of their paints. Look at the labels on paints to find an indication of how lightfast that paint is.

The American Society for Testing and Materials (ASTM) has developed standards that many manufacturers have adopted for testing and labeling their paints. ASTM has set up five categories of paint permanence, but only the top two are of interest here. They are:

Lightfastness Category I (LFI): excellent lightfastness under all normal lighting conditions.

Lightfastness Category II (LFII): very good lightfastness, satisfactory for all applications except those requiring prolonged exposure to ultraviolet light—for example, outdoor murals.

Some manufacturers have their own rating systems, such as four stars, three stars, and so on. A safe way to go is to use only colors rated in the manufacturer's top two categories.

This picture has little detail to carry it. What makes it work is a combination of simple, well-placed shapes, strong value contrasts and vibrant colors. Brown makes use of the fact that complementary colors (such as the purple and yellow in this collage) placed next to one another often produce particularly lively effects.

OFF IN THE DISTANCE
15" × 20"
(38.1cm × 50.8cm)

Do Your Own Testing

Cut strips of the papers you want to test and cover half of each of them tightly with a piece of white rag mat board or other acid-free, white, opaque material. Label them and place the strips in the sunniest spot you can find. Once a month for a year or so, compare the covered and uncovered portions of each strip and note the results. You'll probably find many that stand up very well and a few that fade or undergo a color change.

Adhesives

You need a reliable way to fasten collage pieces to a support. Most often adhesive is used, but sometimes parts are fastened with wire, string, threads, screws and bolts. Brown usually uses adhesive in his paper collages, but in your work, use any method you find necessary to hold a piece in place. If you use such fasteners as wire or screws, they may become an attractive part of your collage.

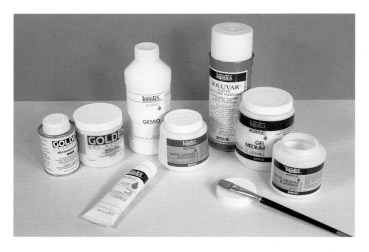

Some of the many acrylic products that may be used in a collage.

ACRYLIC MEDIUMS AS ADHESIVES

Many collages these days are combinations of papers, acrylic paints and other materials, using acrylic mediums as adhesives. Acrylic mediums are strong adhesives and may be used to join non-oily materials. Since acrylic products are non-acidic, they help assure longevity of the material. You may choose from several acrylic mediums, as summarized in the table on page 23.

Mediums may be used in a number of ways. You may coat the back of the collage piece you want to stick in place, or you may coat the part of the support where the piece is to go. If the collage piece is tissue-thin, you may brush medium over the piece after putting it in place, and let the medium penetrate the piece.

A major difference between using dry-mount adhesive and acrylic adhesive is this: Unless you're extra neat and careful, you'll get acrylic medium onto por-

tions of the surrounding collage. Some medium squeezes out around the edges of the piece as you press it in place. When dry, the exposed medium looks shiny, while the rest of the collage may not be shiny. There are three ways to avoid this problem:

1. Use matte medium to minimize the shine.
2. Give the entire finished collage a coat of acrylic medium or varnish, either gloss or matte, to provide a uniform surface.
3. Make sure no medium gets onto the collage's surface.

SPRAY ADHESIVES

Brown routinely uses a spray adhesive to tack the pieces temporarily in place while he is cutting, trying, adjusting. When satisfied with the placement of several pieces, he mounts them permanently using the dry mount press.

The temporary adhesive he uses is 3M Spray Mount Artist's Adhesive. He turns over a collage piece onto a sheet of newspaper, lightly sprays the back, and presses the piece in place on the collage. If he decides to remove the piece for any reason, it comes up easily. Another product you may use for this temporary tacking is 3M Photo Mount Spray Adhesive, which is intended for this kind of use.

PRODUCTS NOT RECOMMENDED

Most household products are not satisfactory for permanent collage work. Many, such as Elmer's Glue-All, are not waterproof—that could give you trouble if you paint over collaged pieces with watercolor or acrylic paint. Others may be acidic. Products such as wallpaper paste are generally not waterproof and are neither as permanent nor as strong as acrylic mediums.

DRY-MOUNT PRESS

A dry-mount press is expensive. Brown is partial to the press; he prefers it to fluid adhesives, and he likes the way the press neatly flattens everything. The presses listed in a recent *Dick Blick* catalog range from a $640 model that can accept a collage up to 24″ (70cm) wide to a $1,250, 36″ (91.4cm) model. Brown's press is a Seal Masterpiece 500T dry mounting laminating press with 26″×36″ jaws. By shifting the collage and pressing a section at a time, it's possible to handle collages larger than the size of the jaws.

Health Tip

If you use smelly or volatile adhesives, pay attention to ventilation. Inhaling the vapors from some solvents, adhesives and mediums can cause all kinds of health problems. Read the labels on the products you're using, especially spray products. Every time you inhale a tiny bit of spray adhesive, for example, you're depositing some of the stuff in your lungs.

DRY-MOUNT ADHESIVES

When dry mounting, you place a thin sheet of special film between two pieces that are to be joined and heat them under pressure between the jaws of a dry-mount press. The film melts and joins the pieces together permanently.

Several dry-mount adhesives, with slightly different uses are available. Some are intended only for joining porous materials and are not usable for plastic or slick pieces. Some are removable using a special solvent, such as Unseal, while others are permanent. The adhesive Michael Brown uses is called PolyMount. It has a neutral pH, and it's available from Washington Mouldings in Kensington, Maryland. They also sell *release paper*, a waxy paper you put between the collage and the jaws of the dry-mount press to keep the collage from sticking to the jaws. Both products come in rolls of several sizes. If you decide to purchase a dry-mount press, it will include instructions on its use and descriptions of the various adhesive films you may use with it.

CONVENTIONAL ADHESIVES

Choosing between a dry-mount press and more conventional adhesives is up to you, but keep in mind that anything that can be done with the dry-mount press can also be done by less expensive means. Michael Brown's unique way of seeing a subject and expressing that subject with pieces of colored paper, not a particular way of fastening down those pieces, is the focus of this book.

ACRYLIC MEDIUMS AND THEIR USES IN COLLAGE

MEDIUM	CONSISTENCY	TRANSPARENCY	USES
Gloss medium	syrupy	transparent	Adhesive for paper, fabric, light materials. Exposed medium is shiny. Can be used as a varnish for finished collage.
Matte medium	syrupy	transparent in single layer; translucent in multiple layers	Adhesive for paper, fabric, light materials. Exposed medium has dull sheen. Can be used as varnish for finished collage, but not in multiple layers—too much layering will cloud the picture underneath.
Gel medium	creamy	transparent	Adhesive for paper, fabric, bark, metals—anything except the heaviest, thickest collage pieces. Exposed medium will be shiny.
Matte gel medium	creamy	translucent	Adhesive for paper, fabric, bark, metals—anything except the heaviest, thickest collage pieces. Exposed medium will have a dull sheen.
Modeling paste	very thick	opaque	Dries rock hard. Can be used to make three-dimensional, textured passages. Can be cut, scraped, painted when dry. Thick areas may take hours to dry throughout.
Gesso	creamy	opaque	Similar to white acrylic paint, but with added tooth. Used to coat an acidic material to help seal off acids before painting or collaging.

To get a feel for the holding power and other properties of the acrylic mediums, experiment with them *before* using them in a collage. Try gluing down pieces of various materials to a variety of surfaces—shiny surfaces, painted ones, dark and light surfaces, and so on. If you're about to add something questionable to the collage, such as a piece of smooth metal, try a sample of it first on a test sheet to be sure it will hold. Glued-down pieces that don't stay glued can make a mess on the surface of your collage.

Tools

Unless you choose to dry mount your collages, as Brown usually does, you need only the simple tools shown below. If you're a painter, you probably have most of these already in your studio. All of these items are inexpensive.

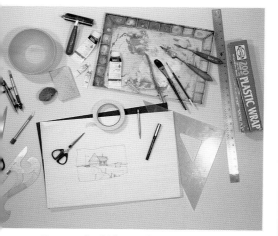

You can build beautiful, complex collages using these simple tools.

Keeping Track

As you accumulate materials, especially papers, you may lose track of their names, where you got them and their characteristics. Start right away to keep a sample of every paper, all the same size, in a ring binder. Write on each sample all the information you think will help you in the future: name of the paper, where you got it, cost, acidity, lightfastness.

TOOL	USED FOR
Craft knife	Cutting all thin materials, such as papers and fabrics. Brown constantly uses the tip of the blade to pick up a piece of paper. Change blades frequently to keep edges sharp for clean cuts.
Scissors	Cutting large rounded shapes, fabrics, etc.
Plastic triangle	Straightedge for most cuts; also, use the square corner to check shapes that you want to be square.
Ruler	Straightedge for long cuts. A strip of fine sandpaper glued to the bottom of the ruler will keep it from shifting as you cut.
French curve	Drawing and cutting curved pieces of paper.
Palette	Watercolor or acrylic paints.
Brushes	*Paintbrushes* for laying in watercolor or acrylic, and *pasting brushes* for applying adhesive to a collage piece. Adhesives are hard on brushes, so use cheap ones, not your good paintbrushes.
Water containers	Cleaning paintbrushes and pasting brushes.
Brayer	Pressing pieces into place.
Plastic kitchen wrap	Covering a piece as you press it into place—protects collage from dirty hands and errant adhesive.
Sponges	Dabbing on paint when you're trying to create textures.
Pad of tracing paper	Sketching.
Pen or pencil	Sketching.
Compass	For drawing circles; or, with a blade instead of a pencil, use it to *cut* circles.

Workspace

A painter doesn't need a whole lot of space—just enough room for some paints, brushes, a palette and the painting in progress. A collage artist needs more—space for laying out the papers and other materials from which pieces are cut to build the collage. It's frustrating to have to search through heaps of papers to find that one little piece you know is in there somewhere.

So try to arrange for a lot of extra working surface beyond the space where your collage is lying. Your space doesn't have to be one continuous tabletop; it can be a number of surfaces, such as a row of card tables.

Some collage artists work at an easel rather than a table. If you choose this method, you'll need a sturdy easel—one that won't fall over when you press a piece of material onto your collage.

PROTECT YOUR WORK SURFACE

From Adhesives. If you're using acrylic adhesives, protect your work surface with a layer of kraft paper or newspaper or, as suggested in *Creative Collage Techniques* (North Light, 1994), heavy plastic freezer paper. Available at the grocery store, this (or any similar plastic) will protect your worktables from being marred by adhesives. Whichever type of protection you use, tape strips together to completely cover your tables, and tape the edges to the tables to keep the protective cover from slipping.

From Cutting Tools. Place something between the table and the material you're cutting to protect your worktable. Many people use a piece of mat board, but that quickly gets shredded and must be replaced. Brown uses a sheet of a rubbery product called Borco board. Borco has a self-healing surface—it closes up after you slice into it, so the surface remains smooth enough for repeated cuts.

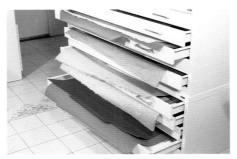

Flat file drawer storage. For papers, use shallow drawers to make things easier to find.

STORAGE

Serious collage artists need serious storage! When you need that textured paper you bought a year ago, you want it now.

For paper storage, Michael Brown uses a couple of large flat file cabinets that have many large, shallow drawers. He has a total of twenty drawers, and that's still not enough. Deep drawers are self-defeating because you have to rummage through too many layers to find what you're looking for. Deeper drawers, however, may be suitable for storing other objects, such as stones, bark, metals, weeds, leaves and twigs.

In the shallow drawers, Brown keeps large sheets of paper, but also uses large envelopes to keep track of smaller pieces. One envelope is labeled "fabrics," and in it he has many small pieces of cloth he uses for such collage elements as flags, window curtains or quilts. Another envelope contains pieces of paper with attractive torn edges.

It's a good idea to organize and label your file drawers. Use separate drawers for watercolor paper, illustration board, pastel paper, flecked paper, fibrous paper. Organize by color—earth colors, blues, reds. Keep magazines on a shelf, but save their cuttings in a drawer.

The storage system is up to you, but some form of organization will add a lot of pleasure to your efforts and save you significant amounts of time.

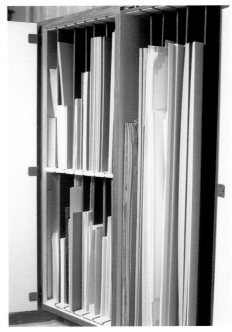

Vertical storage slots for rigid items such as mat board, illustration board and foamboard.

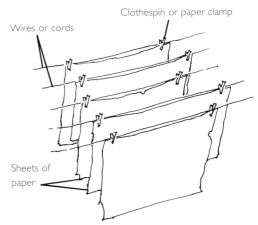

Hanging storage. Another way to store papers is this "clothesline" method. String wires or cords parallel and close together and hang papers from them, using clothespins or other clamps. You can quickly spot the paper you want. An added advantage is that air can circulate around the papers, which should prevent mildew—an occasional problem with drawer storage.

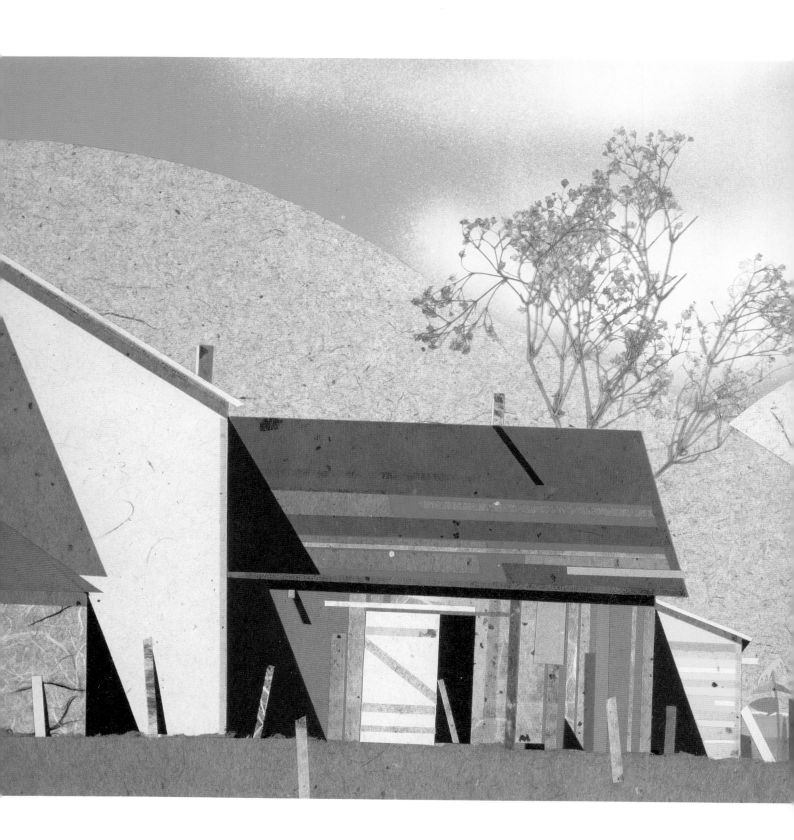

Collage Techniques

Making a collage is conceptually simple. You begin with an image in your head or on paper, cut and shape pieces of materials to fit that image, and fasten the pieces to a support. This chapter describes the techniques that Michael Brown and others use to carry out those steps.

SUNFLOWERS
12½" × 18" (31.8cm × 45.7cm)

Drawing

If you have a good image in your head, you may not need an elaborate drawing. Brown often begins either with no drawing or only a simple sketch. Working without a drawing allows the flexibility to wing it and change course many times as the collage develops. You may, however, prefer to plan a picture in some detail first and use a detailed drawing as a guide. It doesn't matter which camp you're in—choose the method that works for you.

If you decide to do a detailed drawing, there are at least three ways to use it in building your collage:

1. Draw on a separate piece of paper and keep it alongside your collage as a guide. This is how Brown uses a drawing.
2. Draw directly on your support. This presents the difficulty that you begin

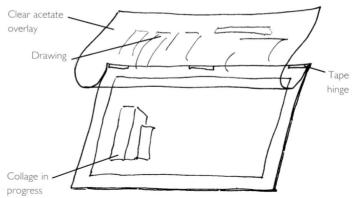

Clear acetate overlay

Drawing

Collage in progress

Tape hinge

Using an acetate overlay to preserve your drawing.

to cover up the drawing as soon as you begin pasting down parts of the collage. This method can help you get started, and you will probably have completed the main shapes in your collage by the time the drawing is covered. Then you can finish without doing any further drawing or you can draw more detail on top of the layers of collage you have so far.

3. Draw on an acetate overlay. Flip the overlay down over your collage as often as necessary to check the positioning of a piece before you glue it down. In this way, your drawing is never lost. This is a technique favored by collagist Robert Kilvert, whose work is shown in a demonstration at the end of chapter three and also in chapter five.

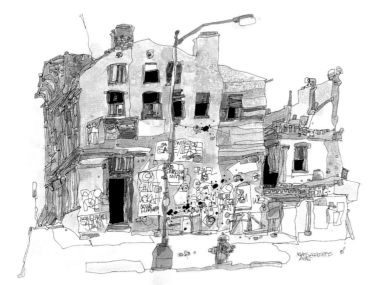

Sketch Constantly
Working rapidly, Brown does many drawings such as this. He adds the color later in the studio. Constant sketching helps him to build a mental store of information that later becomes useful in a collage or a painting.

MASSACHUSETTS AVENUE
Pen and ink and watercolor
9″×11″
(22.9cm×27.9cm)

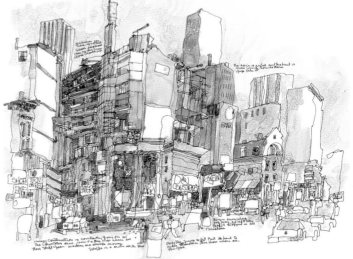

Capture the Essence
Brown works standing up, sketching rapidly on a pad with a Rapidograph technical pen. This drawing took about a half hour, except for the color that he added later in the studio. Most of his drawings are done in nearly continuous motion, like contour drawings, with the idea of capturing the essence of a place. He has assembled a selection of these drawings in a booklet called *Washington D.C.*

BUSY CITY
Pen and ink and watercolor
9″×11″
(22.9cm×27.9cm)

Cut and Tear

CUT

Use scissors or a sharp blade, such as a craft or utility knife, to cut most papers. For fabrics, scissors are usually best. When cutting with a knife, your cutting surface should be smooth and firm. Mat board works well, but after a time it will become so shredded by cuts that it will have to be replaced. A better cutting surface is Borco board (or similar products), available from many art supply stores and catalogs. It has a firm, rubbery surface that lasts long under repeated cuttings before it has to be replaced.

You don't always have to cut a piece of paper away from the collage. Some-times you'll lay paper over the collage and cut it to fit a space. In this case, it's important to use a sharp blade and use only enough pressure to cut through the piece of paper but not into the collage underneath.

TEAR

Often you may wish to tear a paper rather than cut it. A torn edge has a different quality from a cut edge. The torn edge can represent the ragged shape of a flower or the shimmering circle of the sun or the edge of a weedy foreground.

The quality of a torn edge depends on the paper you use and how you tear it. Some papers, especially handmade ones, tear nicely in any direction, since their fibers are arranged randomly. Others, such as machine-made papers, tend to tear in one direction—the direction in which the fibers lie. A little experimenting will quickly demonstrate how your particular papers tear.

Handmade or mouldmade watercolor papers yield especially attractive torn edges. If you paint the paper first, let it dry, and then tear it, you'll get a nice, white torn edge that contrasts beautifully with the painted surface of the paper.

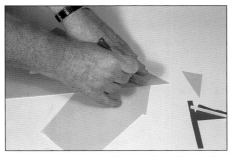

You can cut paper with a knife and straight-edge, as shown here, or cut freehand without the straightedge.

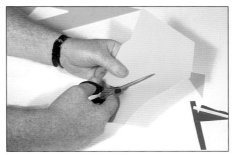

Sharp scissors may be used for cutting paper or fabric. They're especially useful for cutting curved shapes.

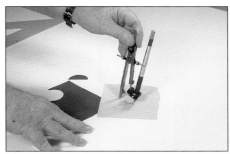

A compass with a blade in one leg is useful for cutting round shapes.

Give Edges Variety

Tearing a paper alongside a straightedge. You may also tear freely without a straightedge to get curved or irregular edges. The surface of this paper is colored; the white torn edge provides an attractive contrast.

Permanent Mounting

There are two common adhesives used for attaching a piece of paper or fabric to a collage support: dry-mount adhesive and acrylic mediums. For heavier, more tactile collages, other means are sometimes used as well—for example, a heavy piece of metal may be secured in place using wire or thread or even screws or bolts.

TEMPORARY TACKING

Brown routinely uses a spray adhesive to lightly stick a piece of the collage in place until he's sure it's right. He uses 3M Spray Mount or 3M Photo Mount. Both allow a piece to be lifted without pulling up what's underneath, provided you don't use too much spray.

DRY MOUNTING

Dry mounting involves the use of a relatively expensive tool, a dry-mount press. If this is not something you care to invest in, you can do with acrylic adhesives, described later, anything done with the dry-mount press.

The steps in dry mounting are:

1. Each sheet of paper you use must first be backed with a sheet of dry-mount adhesive film. You place the sheet of paper, the sheet of dry-mount film and a sheet of release paper between the jaws of the electrically heated dry-mount press, close the jaws and turn on the heat. The film melts and attaches to the back of the sheet of collage paper. The paper is then ready for later use in a collage.

 Important: The release paper mentioned is a waxy paper that separates anything you are dry mounting from the jaws of the press. Without the release paper, your work will stick to the jaws.

2. Cut the shape you want from the sheet of previously backed collage paper and place the piece on the collage support. Tack it in place with spray adhesive to keep it from shifting.

3. Insert the support and the piece of collage paper into the dry-mount press and heat. The film on the back of the collage paper now melts again and sticks to the support.

 NOTE: There is no need to heat one piece of collage paper at a time; you may arrange several pieces and heat them all at once.

Avoid Disaster

Be sure the waxy release papers that separate your collage from the jaws of the press are absolutely clean. If you get any foreign materials on them, you may end up with a blotch in your sky area too big to make into a sparrow.

Glue Lightly at First

Turn the collage piece over onto a sheet of cheap paper, such as newsprint, and lightly spray the back with some adhesive. By tacking pieces in place, you allow yourself many changes of mind. Another advantage of temporary tacking is that you can lift the edge of a tacked piece and slip another under it.

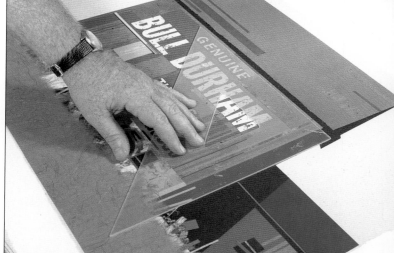

Align Elements Carefully

Before fastening pieces firmly in place, check on critical alignments. Here, Brown uses a plastic triangle to square the roofline with the vertical side of the building. Keep in mind that you don't need everything to be squared and aligned—some things work better if they're more relaxed and not too perfect.

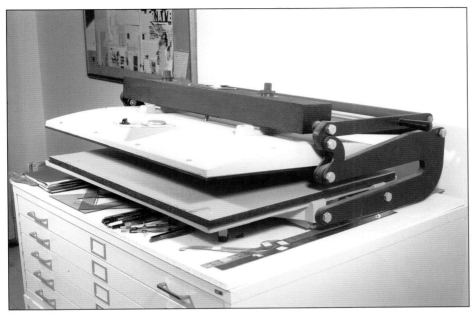

Know Your Press
A dry-mount press. Operating instructions differ slightly from one press to another, but each press comes with detailed instructions for its use.

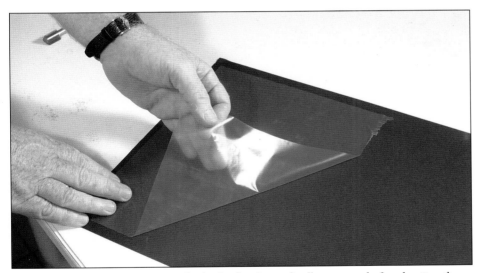

Lay a sheet of dry-mount film on the back of a sheet of collage paper before heating them together in the press. It's best to back your papers ahead of time and store them for later use. If you wait until you actually need a paper, you slow the collage-making process.

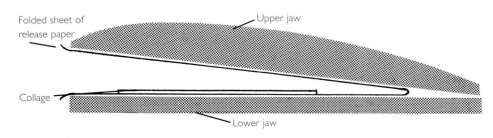

Folded sheet of
release paper

Upper jaw

Collage

Lower jaw

An Alternative to the Dry-Mount Press

If the idea of dry mounting intrigues you, but you're not sure it's worth the price of a press, try this first:

Use an ordinary clothes iron to substitute for the press. Try the iron at different heat settings ("cotton" should be about right), and use it first to back some pieces of collage paper with adhesive film, just as you would in a press. Then use the iron to adhere collage pieces to a support, again the same as you would in a press. The heavier the collage papers, the longer you'll have to press with the iron to get the adhesive to melt.

Don't forget, you need the waxy release paper between the iron and the paper in both operations. Buy the release paper at the same time you buy sheets of dry-mount adhesive film—ordinary kitchen waxed paper is not suitable.

If you like the results you get, and if you're doing relatively small collages, you might continue to use the iron. However, this procedure is more cumbersome and less predictable than using a press.

Release Paper
Dry-mount press with collage in place. When the jaws of the press are closed, there is firm pressure exerted against the collage. Pressure, along with the heat that melts the adhesive film, assures a strong bond. Brown sets the temperature at 200°F for two minutes.

Notice there is a sheet of special waxy paper, called *release paper*, between the jaws of the press and the collage. This paper must always be used to keep the piece you are mounting from sticking to the jaws of the press. The release paper is also used when backing your papers with adhesive film.

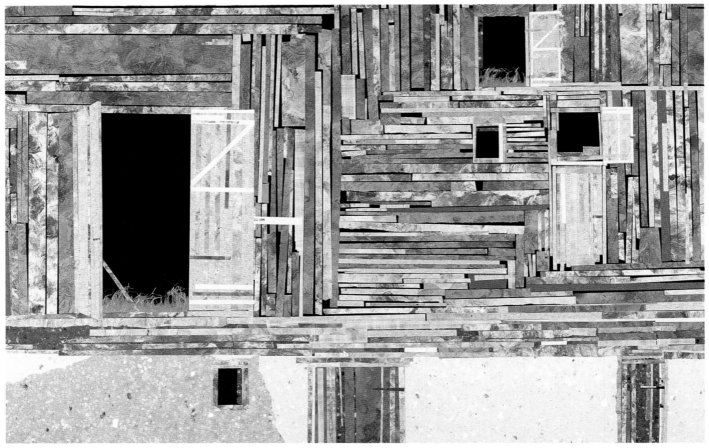

Brown began this pattern picture with a sheet of black paper. He used no paint and worked without a sketch. Most of the black areas are from the original black sheet, but one or two of the smaller black accents were laid on top of the board siding.

BARN SIDING
30" × 40" (76.2cm × 101.6cm)

ACRYLIC ADHESIVES

The most popular adhesives used in collages are acrylic mediums, discussed in chapter one. To use them, coat the back of a collage piece with medium and press it in place, taking care not to let excess medium squeeze out around the edges and mar the surface of the collage.

In all your work with collage, it's important to keep your hands clean to avoid marring the collage surface. Clean hands are especially important when using acrylic adhesives, because once they dry, they're nearly impossible to remove cleanly. You'll need a surface, such as a sheet of newsprint or newspaper, on which you lay a collage piece upside down and coat it with adhesive. It's a sure bet you'll get some adhesive on the newsprint around the edges of the collage piece as you brush on the adhesive. Be careful not to lay the next collage piece down on that sticky area of newsprint.

Just as in dry mounting, get in the habit of tacking collage pieces in place temporarily with spray adhesive until you're sure of your placement, then use acrylic adhesive to secure the piece permanently.

Elbow Room

Give yourself the freedom to change your mind as a collage progresses, just as you might if you were doing a painting. This medium can be a lot of fun, as long as you don't feel too bound by rules.

When you work at a collage, feel free to constantly change your mind, shift directions, break some rules. If, in the middle of a collage, you find a bit of paper you like, move it all over the picture—find an excuse to use it.

Brown cuts the pieces he likes first, not necessarily in the order they might most logically be glued down. Often the picture tells him what to do next—for instance, if he drops a piece of black paper on an area meant to be green, he'll use the black if it intrigues him.

Painting in a Collage

Many collages combine paint with papers and other materials. The best paints to use are watercolors and acrylics, both compatible with acrylic adhesives and most other collage materials. Putting a partly painted collage into the dry-mount press is no problem, provided the paint is dry.

Here are some of the ways you may use paint in a collage:

BACKGROUNDS

Skies and other backdrops may be painted before beginning to collage. Brown often uses painted skies to set a mood for the picture.

COLORING PAPERS

As mentioned in chapter one, you may prepare your own collage papers by painting white papers with watercolor or acrylic paints.

DETAILS

Any part of the collage, from a small detail to a major element, may be painted. There may be times when small items, such as birds in the distance, can be better handled with a dab of paint than with tiny bits of paper.

TEXTURES

Watercolor or acrylic paint may be used for suggesting textures (see some of the demonstrations in chapter three).

SPATTERING

Spattered paint can suggest textures, such as weeds or weathered surfaces. It can also represent snow. Flick watercolor or acrylic paint by riffling the bristles of a brush, such as a toothbrush, or gently hit a paint-filled brush against the edge of your hand to jolt droplets of paint loose. Whatever method you use, make some trial runs first to avoid ruining the surface of your collage. A common mistake is to use a brush loaded with paint that is too fluid, resulting in big wet blobs rather than small specks of paint. If you're spattering for a snowy effect, remember that snow doesn't necessarily show up as white. If you're viewing falling snow against a bright background, some of those white flakes may appear gray or black!

Laying in a watercolor sky on 300-lb. (640g/m²) paper that also serves as the collage support.

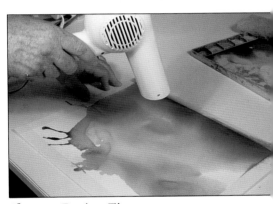

Shorten Drying Time
You can save time by speeding up the drying of water-based paint. An ordinary hair dryer works well. If you're drying a really wet area, such as this watercolor sky, hold the dryer far enough above the painted area that the airstream doesn't blow the paint around. In this illustration, Brown has moved the dryer close to the paper because drying is almost complete and there is no longer a danger of disturbing the paint.

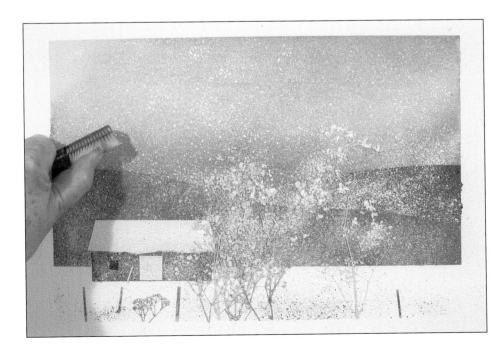

Quick, Easy Texture
Paint may be flicked from a paintbrush, a toothbrush or even your fingers.

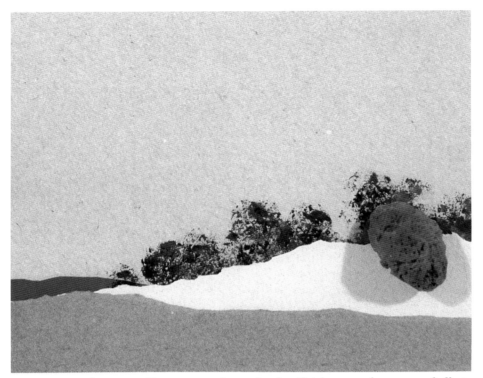

Sponging paint for texture. Use a variety of natural and artificial sponges for a range of effects.

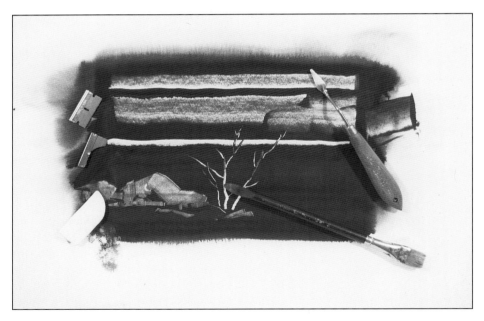

Lay on some thickish paint and scrape some of it away to reveal color and texture of the area beneath the paint.

SPONGING

A sponge is often handy for special textures. To get an effect like the one shown here, spread out a mixture of fairly thick watercolor or acrylic paint on the palette. Dip a small natural sponge into the paint and then gently dab the paint onto the picture. Be careful not to twist the sponge against the picture—that will smear the paint, and you'll lose much of the textured look you're after. Here the idea was to suggest foliage just beyond the hill, so the edge of the hill must be kept free of paint. Do that by laying a piece of scrap paper over the edges you want to protect or, as we did here, sponge the paint on before fastening down the torn paper representing the hill. If you use acrylic paint, clean your sponge before the paint has time to harden and ruin its soft texture.

SCRAPING

You can get a variety of textured effects by scraping through damp paint, either directly on the surface of your collage or on separate sheets of paper that you later cut for use in the collage. The harder you scrape, the more you reveal what's underneath the paint. Scraping can suggest boards, rocks, trees—anything you can imagine. Use thick watercolor paint and a variety of scrapers: a painting knife, a brush handle, a spatula, a razor blade and a broken razor blade. The results you get will vary depending on the wetness of the paint, the particular pigments you use and the texture of the surface beneath the paint (here the surface was smooth; a textured surface would yield different, more varied results).

STENCILING

For signage or graffiti, stenciling is often helpful (see the *Bull Durham Barn* demonstration in chapter three). You can buy paper stencils in a variety of sizes at art supply stores, or you can cut your own.

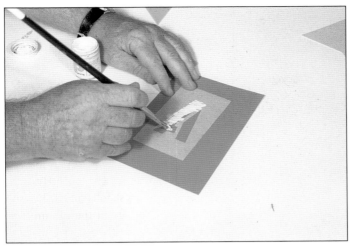

Dabbing acrylic paint through a stencil.

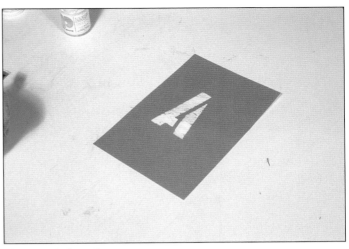

The stenciled result.

SPECIAL EFFECTS

You can use papers in ways other than simply cutting and gluing them down. For example, try gluing thin oriental papers over an area, then wetting the paper with water and dropping paint into the wet paper. The paint will spread in wonderful, unpredictable ways.

Also, crumple papers to introduce random creases before gluing them to the collage. Try crumpling a piece of ordinary bond typing paper into a tight ball, smooth it out flat, dampen it with plain water and paint it with watercolor or acrylic paint (see illustration at right). The paint will tend to collect in the creases.

Try this with a variety of papers, such as thin tissue, rice papers and watercolor papers. Depending on the type of paper, how much you crease it, and the paint you use, you'll get a variety of beautiful, randomly textured effects. You can use an entire sheet painted in this way as a backdrop, or you can tear or cut pieces for smaller areas.

Crumpling for texture.

Effective Elements

This is one of Brown's favorite collages. The support was Bainbridge acid-free watercolor board. He laid in the sky with acrylic paint and did the rest with papers, cloth and some string. He spent a long while fashioning the clothes from bits of cloth. The string for the clothesline is fastened down with a bit of spray adhesive. On the facing page are some notes to indicate what helps make this picture effective.

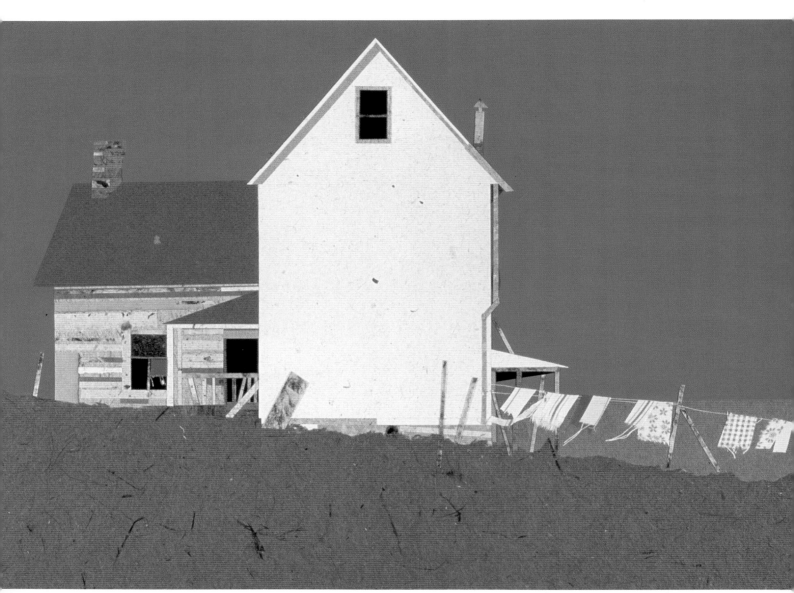

WASH DAY
15″×20″ (38.1cm×50.8cm)

AN ANALYSIS OF *WASH DAY*

Good variety of shapes, mostly linear
but relieved by curves

Harmonious set of colors,
variety of textures

Sharp dark accents for liveliness
and sense of depth

Odd-shaped chimney
for interest

Eye-catching light
value against
dark-value
background

Jog in drainpipe
breaks its long shape

Subtle color
variation in siding

Some left-leaning
elements to counter
many right-leaning
posts

Variety of horizontal
and vertical elements

Clothes at angle (blown by breeze)
relieve static elements in picture

Fibrous paper to suggest
foreground texture

Variety in rails

Bit of color to break up
black of window

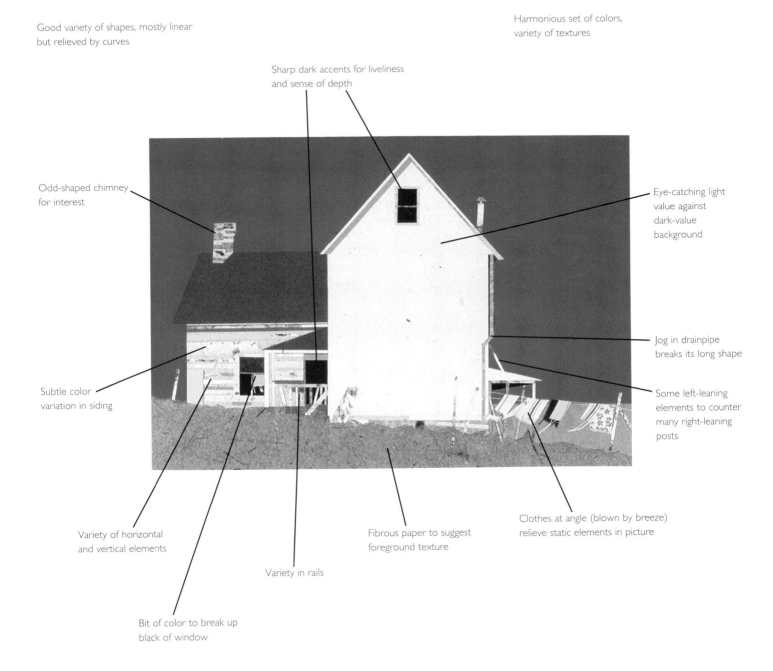

Finishing, Matting and Framing

When you are finished playing and want to preserve this beauty for posterity, you may need to flatten and varnish it.

FLATTENING

If you use a rigid support, you won't need to flatten the collage. But if you used a thin support, such as watercolor paper, some fixing may be in order. The simplest method is usually to glue the finished collage to a stiff backing (or glue the thin support to a stiff backing at the outset!). Use acrylic gel medium and pile on enough weight to flatten everything while the medium dries. It's best to let it dry overnight.

If your collage is three-dimensional, you probably can't put weights on it without damaging its surface, but you may be able to glue it to a stiff backing and secure it around the edges with paper clamps until the adhesive dries.

VARNISHING

You may hang your finished collage as is, without frame or varnish. The life expectancy of the picture then depends on the materials used and the degree of exposure to physical damage. At the least, the collage will collect dust over the years.

If you don't frame the collage under glass or Plexiglas, it's advisable to protect it with varnish. If you use acrylic mediums as your adhesives and some adhesive shows on the surface of the collage, the look may be so uneven (some areas dull, some glossy) that a coat of varnish will be necessary to make the surface appear uniform.

A coat of acrylic medium provides some protection, but acrylic paints and mediums are porous, and dirt will eventually settle in the pores. Instead, choose a nonporous varnish such as Liquitex Soluvar, Winsor & Newton Acrylic Gloss Varnish or Winsor & Newton Acrylic Matt Varnish.

If your collage contains materials of questionable lightfastness, a good varnish choice would be one containing ultraviolet light inhibitors to help prevent fading.

MATTING AND FRAMING

Like any picture, a collage may be matted and framed to show it off well. If the collage is lumpy or three-dimensional, matting may not be feasible.

Just as you should use the most permanent materials you can in your collage, you should select mats that are acid-free. If you're framing under glass or Plexiglas, you may choose the more expensive varieties of glass or Plexiglas that inhibit ultraviolet light and extend the life of your picture.

Any frame is suitable for a flat collage. For three-dimensional pieces, however, you have two choices: Either enclose them in a Plexiglas box deep enough to accommodate the thickness of the collage or use a regular picture frame with spacers to allow for the thickness.

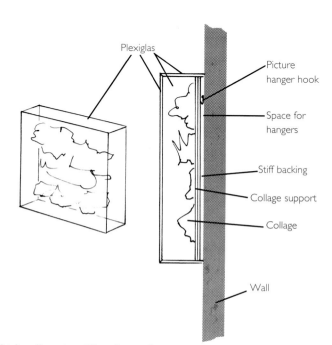

A thick collage in a Plexiglas enclosure.

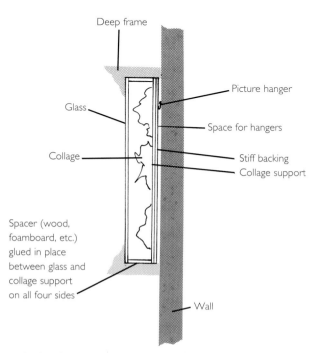

A thick collage in a conventional frame with spacers.

Put It All Together

Starting with a sheet of acid-free illustration board, Brown built up this highly tactile collage using acrylic gel matte medium as his adhesive. He did not use the dry-mount press. He painted the sky with acrylics and then worked forward in the conventional manner. The dark distant tree line and the water area are colored papers. The foreground is a thick, fibrous material he found in an art supply store. The buildings each began as pieces of illustration board that Brown colored and textured with combinations of acrylic paints and colored papers. *Maine Lobsters* was painted using stencils. The foreground clutter includes pieces of bark paper, some shreds of bark, pieces of hemp, and some heavy string that Brown coiled around his finger and then pressed onto the collage into some gel medium. He used balsa wood for the crates and, finally, a Rapidograph pen to draw the wires.

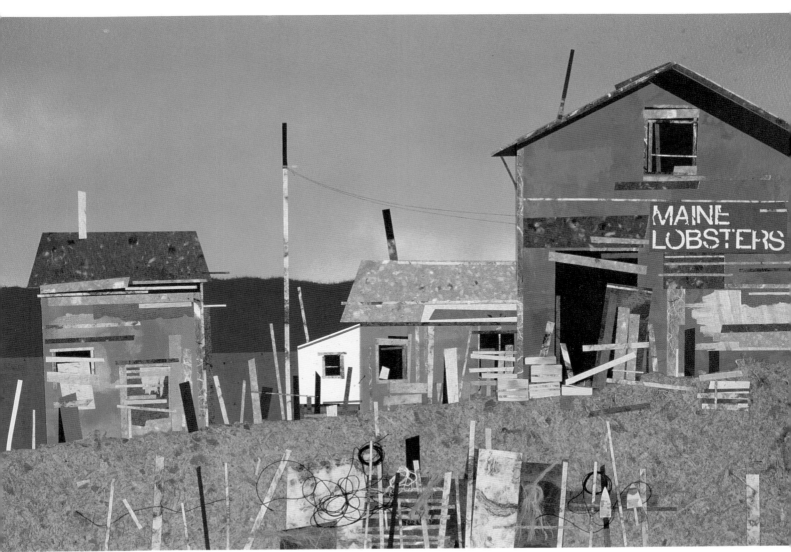

MAINE LOBSTERS
20″×30″ (50.8cm×76.2cm)

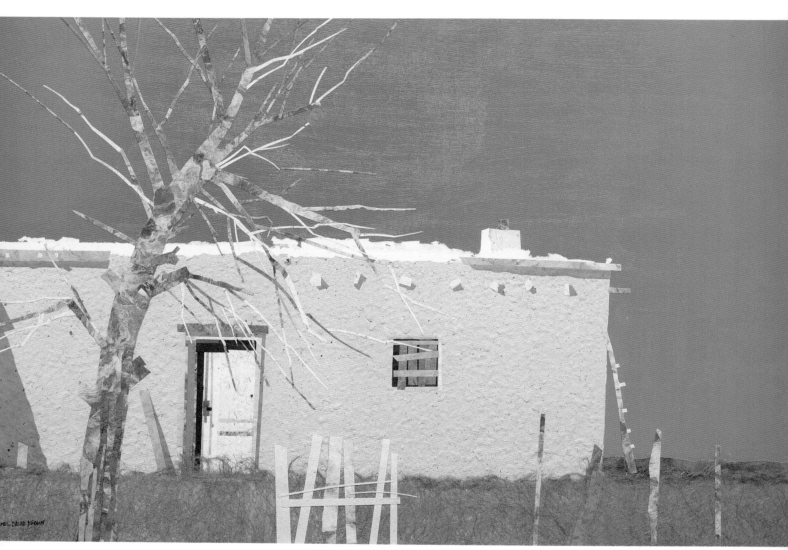

RANCHERO
22"×30"
(55.9cm×76.2cm)

chapter three
Let's Get Started!

ASSEMBLING THE COLLAGE

These twelve demonstrations show you how to assemble a variety of collages in easy-to-follow steps. The first four demonstrations use simple, inexpensive colored construction papers. Later demonstrations introduce a greater variety of materials, such as bits of fabric, pieces of screen, paint, magazine clips and papers that are more permanent and more expressive than construction papers. Some of those papers are solid colored, while others are textured with a variety of flecks and fibers.

Design Tips

- Build a good foundation before you get to the details. In a landscape, lay out sky, land or water strips early; in a portrait or still life, establish a background first. If your composition isn't sound after the first large pieces are in place, no amount of fiddling with details will save it.
- A collage can take on a life of its own—no matter what your original travel plan, allow for detours.
- Choose colors that please you even if they don't make literal sense. Want a red sky or a purple nose or a blue field? Do it and then play other colors against those you've chosen. There is no law that says you need colors to be literally correct even in a realistic landscape.
- Pay attention to value—the lightness or darkness of a color. Strong, well-placed value contrasts can give your work a zing that humdrum middle-of-the-road values cannot.
- If you paste down a detail and it doesn't seem to work well, throw it out. Don't worry that you've left out a bit of literal information that somebody will point to and say, "Ha! You forgot to cast a shadow there!" Go with your instincts, and do what you feel is right for the picture.
- If you need to do a drawing first, even a detailed one, do it. But try not to let a drawing paralyze you. If you feel like departing from it partway through your collage, by all means do it.
- If you're dealing with mostly rectangular shapes (as in a city scene), use a few diagonals or curves for contrast and relief.
- If you're disturbed by something in the subject that seems boring, such as a long row of windows all lined up and all the same size, do something to disrupt the boredom. Eliminate some windows; make some bigger or smaller; make some odd shaped; put some where they don't line up with the others.
- Understand your subject thoroughly before you attempt to distort it. To distort convincingly, first understand reality.
- Never hesitate to cover up early passages with new and better ones. The beauty of collage is that you can put on all the layers you need to get a result you're happy with.

Winter Scene

Basic Tools

sharp craft knife
straightedge
3M Spray Mount Artist's Adhesive
brushes
compass
sharp scissors
dry-mount press or acrylic adhesive

Materials

construction papers
• white
• light gray
• medium gray
• dark gray
• purple-red
• black
• brown
• deep blue

For the first four demonstrations Michael Brown uses 3M Spray Mount. For the others he uses a dry-mount press, for which you may substitute less expensive techniques, like acrylic adhesives. Brown starts without any preliminary sketch, but he has a good image in his mind. You may prefer to make a drawing first, but remember simple drawings leave you free to move things around and change your mind as you go along. For more complex scenes, you may want more detailed drawings.

STEP I

Background and Support

Use a piece of gray construction paper as the background support. Glue a rectangle of white paper over the entire image size of the collage (it represents snow), and glue over it a piece of deep blue paper for the stream and a medium gray paper for the sky. The bottom of the gray sky area represents the horizon in the picture. The use of gray color for the sky helps set a quiet mood.

The original gray background paper will not figure in the final picture, but it serves as a support to help stiffen the collage.

You witness this phenomenon every day. Distant objects look paler, less intense and cooler in color than near objects. The veil of air containing all sorts of impurities, such as water droplets, smoke and dust, between your eye and the objects causes this. Hazy air not only cuts down the amount of light reaching your eye from the object, but it filters out some of the warmer light (red, orange, yellow) allowing more cooler light (blue, green) to get through. It's because of aerial perspective that a distant mountain, which may actually be red and brown with fall color, may appear to be pale blue.

The farther you are from an object, the thicker the veil of air, and the more pronounced are the effects of aerial perspective.

STEP 2

Introduce Depth

Introduce depth by overlapping three shapes—a distant mountain, a nearer hill and a still nearer tree line. Cut the most distant shape with a craft knife for a smooth edge and tear the next two layers for rougher edges to suggest they are closer to the viewer. Make tapered and interlocking shapes for more visual interest rather than simple horizontal strips. Values (lightness/darkness) range from pale in the distance to stronger in the middle and darker up close. This value change is an example of aerial perspective.

STEP 3

Place Building

Cut the building shape using a muted-red construction paper, in keeping with the somber colors used so far. Place the building off center to avoid having a red bull's-eye at the center of the picture. Notice that the distant curve in the stream gently brings your eye back toward the building. The big, white foreground is a bit too uneventful, so let's add a foreground shadow, echoing the distant mountain. The shadow also serves to nudge the viewer's eye upward into the center of the picture. Try different colors and experiment. For example, Brown tried a blue shadow first, but it was not in keeping with the colors already established, so he decided on gray.

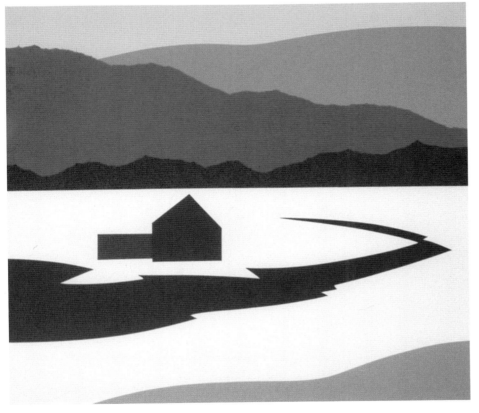

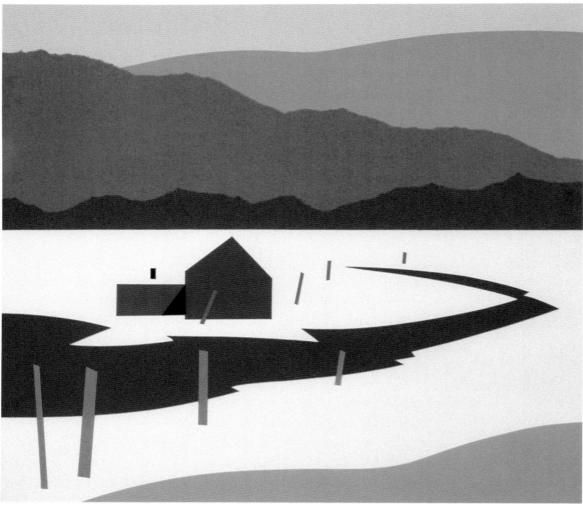

STEP 4

Details

Now it's time for some details—just enough for interest, but not enough to become clutter. If the composition is not effective at this point, no amount of detail will save it. This is a quiet scene where a lot of detail is not appropriate.

The chimney defines the roof, which would be indistinguishable from the snowy ground if the chimney were not there to give us a clue. This is a good example of the use of suggestion. It's often more fun and more effective to hint at something than to be too explicit.

The fence posts diminish in size as they recede into the picture, enhancing the feeling of depth. This is an example of linear perspective—the use of converging lines and diminishing sizes to suggest distance. See pages 64-65 for more on linear perspective.

Torn Edges

When you tear a paper you can get a couple different effects. With softer, thicker papers, you get edges that reveal the inner (in this case, white) fiber of the paper. Use that exposed white edge for striking visual effects that are freer and more natural looking than you could achieve using paint.

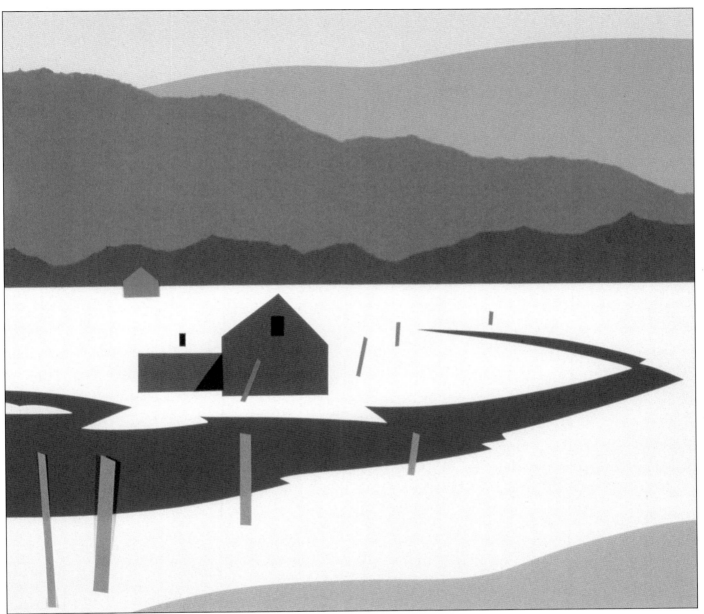

STEP 5

Finish

A few more touches and the collage is finished. A couple of dark accents (a window and a shadow) add interest to the face of the building, and a white hump of snow breaks up the blue of the stream a bit. The small building at the upper left makes the red building, a little less lonesome, and at the same time it breaks the severe line between the white area and the tree line.

Finally, place a white mat around the collage, thus trimming the edges.

Mountains

B rown spent nearly ten years in Colorado and carried away with him images of bold landscapes with intensely blue skies and rugged features. He finds such scenes well suited to the flat, bold shapes of cut paper.

Materials

construction papers
- dark blue
- medium blue
- light gray
- medium gray
- white
- light green
- medium green
- dark green
- black

The collage in progress, showing the simple tools you need: craft knife, straightedge (triangle) and 3M Spray Mount. The flat-sided plastic fitting on the end of the knife keeps it from rolling off the table.

STEP 1

Sketch

Although Brown often works without a sketch, he uses one here—simple, no frills.

STEP 2

Background and Support

Begin with a dark blue backing sheet of construction paper, a color and value that will serve as a lake in the foreground. Glue a strip of intense medium blue across the upper third of the backing.

STEP 3

Add Mountains

Add mountains cut from light gray construction paper.

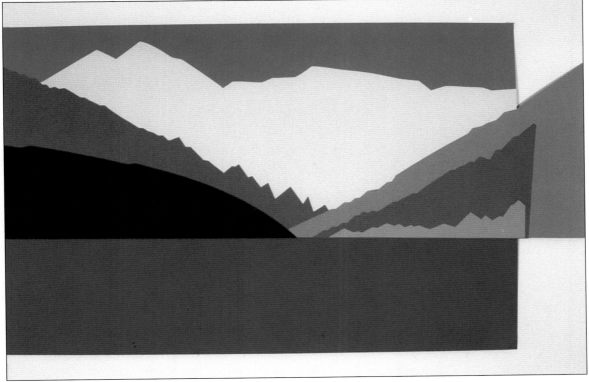

STEP 4

Experiment

Cut several of the next pieces from construction paper and try them in various positions, trimming some, recutting a couple, until you're satisfied with the shapes and arrangements. Then glue them down, working from back to front. Later, trim the excess paper that extends beyond the edges of the picture.

Have fun cutting, rearranging and trying pieces!

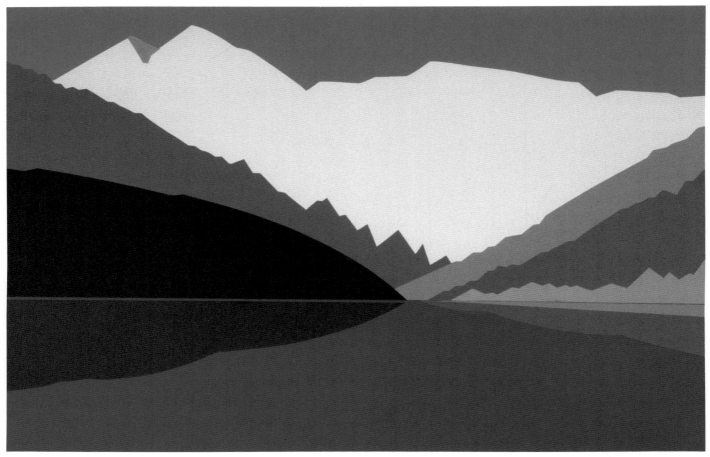

STEP 5

Reflections

Now add several strips to suggest reflections. Include only what you feel the picture needs, bending the strict "rules" of reflections. You may wonder: Shouldn't the light mountain show a reflection in the lake? The answer is a definite *maybe*. Depending on the viewer's position and how far away from the viewer the mountain is, it actually may not reflect. (See page 52 for more on reflections.)

What Really Matters?

Although his goal is to suggest realism, Brown always thinks in abstractions: Is this an engaging shape? Do these shapes work well together? Do these colors feel right with one another? He rarely asks: Would a sky be that blue? Would a near hill be that dark? Are real hills shaped this way? What really matters is a good design, exciting color combinations, the right mood, pleasing textures—in other words, everything but photographic realism.

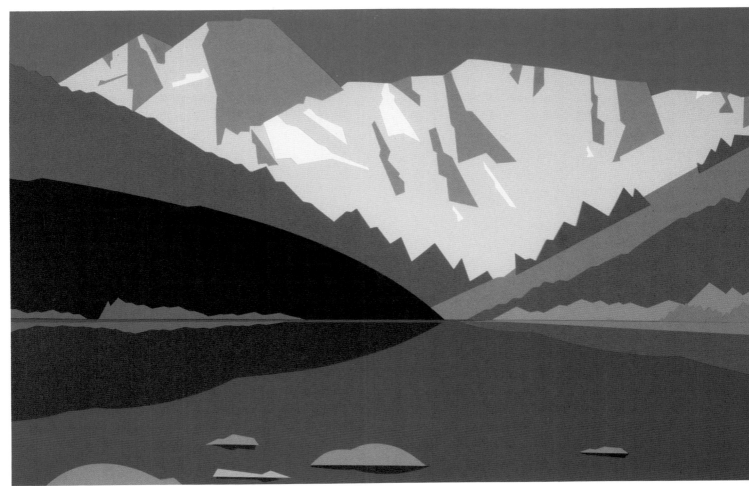

STEP 6

Shadows and Details

Now work on the shadows and crevices in the distant mountain. This is a ticklish area of the picture—easy to overdo—so tack pieces on lightly till you're satisfied with their shapes and positions. Imagining and placing the shadows takes time and patience. If you get stuck, go on to other areas, such as the reflections, and then return to the mountain. Whenever you place shadows, keep in mind the position of the light source (the sun, in this case) and place the shadows away from the light.

Finally add a green strip between the dark hill and its reflection to break up that dark area a bit. Finish with a few boulders and their reflections in the water.

Keep It simple

All the way through the collage process, ask yourself, "Do I need that piece of paper in that spot, or is it too much? As any painter knows, it takes a lot of restraint to keep from adding unnecessary details.

Still Life

Before tackling more complicated still lifes, you may want to try some simple, playful, Matisse-like pictures. Be a child again—use a few simple shapes and distort all you like.

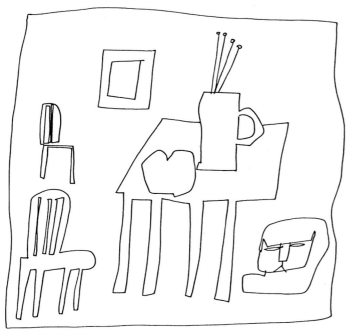

STEP 1

Sketch

Here is Brown's initial concept. Let's see how the final collage compares with the sketch.

Materials

construction papers
- dark blue
- bluish gray
- light gray
- medium yellow
- white
- light violet
- dark violet
- brick red
- black

STEP 2

Background and Shapes

The background color is important, because every color you lay over the background must relate well to it. Brown selected a black construction paper for the background here, but your choice may be different.

Cut pieces using only a craft knife and sometimes a straightedge. Although it isn't necessary to draw your shapes on the construction paper, you may wish to draw a few guidelines before cutting. The advantage in *not* drawing is that you may proceed more freely, with fewer constraints, and have more fun. You may ruin a few pieces of paper, but in collage, that's normal—and the piece you ruin today will come in handy in tomorrow's collage.

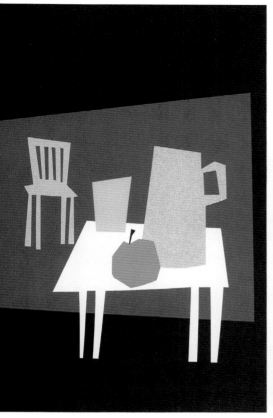

STEP 3

Experiment and Create Depth

Brown cuts the four main shapes freehand and moves them about until he's satisfied with their relationship to one another. He introduces some depth by making the chair a bit smaller than it would be if it were as close to you as the table. The black apple stem echoes the black background.

Overlap

One of the many ways of introducing a feeling of depth in a picture is to overlap objects. In this collage, overlapping the apple and the pitcher automatically tells the viewer the pitcher is farther back than the apple.

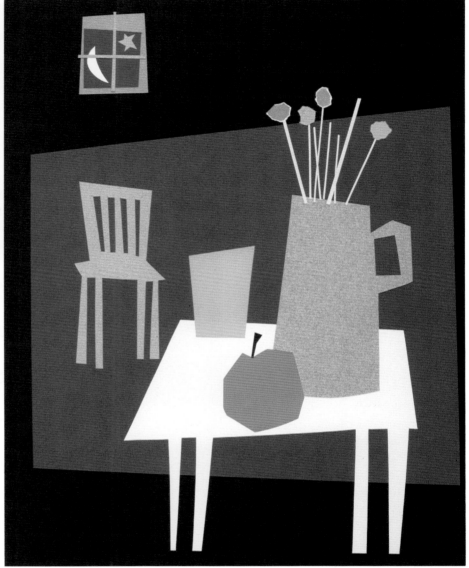

STEP 4

Details

In the initial sketch, there was a picture frame at the upper left. Now it's become a window, through which you see the moon and a star. We're still dealing with "realism"—recognizable objects in a familiar world—but we're allowed to play and let our imaginations go a little crazy.

The final touches are stems and flowers. Instead of cutting the flower heads, Brown tears them. The result is an attractive narrow fringe around the outer edges of the flowers. Notice he eliminated a chair and the cat.

STILL LIFE
16" × 12"
(40.6cm × 30.5cm)

Reflection Pointers

You see an object because light from the object travels in a straight line and reaches your eye. A reflection is an image formed by light that reaches your eye indirectly. Instead of coming straight to your eye, it first bounces off some surface. If you do the mirror experiment shown here, you'll find some unusual things happen. For example:

1. You may see under a roof overhang in a reflection even though you only see the top surface of the roof when looking directly at the house.

2. Tilting a pole right and left causes the reflection to tilt in the same direction. But tilting the pole backward and forward causes the length of the reflection to change relative to the length of the pole.

3. The smaller tree casts a somewhat longer reflection than the taller tree because it's nearer the viewer.

4. Often people confuse shadows with reflections. A *shadow* is an area that receives less light than surrounding areas because something is blocking the light source. A *reflection* is an image you see when light bounces from some surface before reaching your eye. Shadows and reflections are independent. You can show this in the mirror experiment by moving the light source (in this case, a lamp at the left). You'll see that the direction and length of shadows change but the reflections stay the same.

Many things affect reflections: distances between object and observer, position of observer, and so on. Look at the two mountain cutouts in the mirror setup. They're both the same height, but one is farther back than the other, and only its tip reflects. If it were pushed back farther, none of it would reflect. Other situations also result in no reflection where you might expect one. For example, water rippled by the breeze might scatter light in a way that little or no reflection occurs.

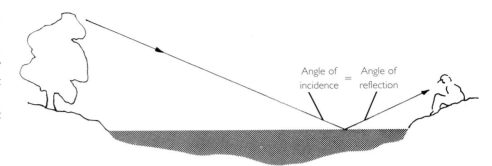

Angle of incidence = Angle of reflection

It's a simple rule of physics: When light is reflected, the angle of incidence equals the angle of reflection. In other words, when light strikes a surface at a particular angle, it bounces away from the surface at that same angle. Light obeys this rule and does not bounce around randomly. Knowing this, you can figure out a lot of reflection problems.

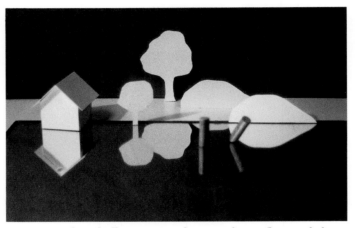

Here's a simple and effective way to figure out how reflections behave. Lay an ordinary mirror flat and position various objects around it. Observe from across the mirror (as though you were watching from across a pond) how objects compare with their reflections. Change your own position—higher, lower, left, right—and see how your position affects the reflections you see. Then move the objects around and see how moving them changes their reflections.

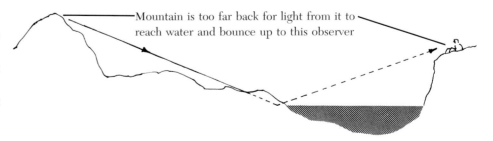

Mountain is too far back for light from it to reach water and bounce up to this observer

We raised a question in the *Mountains* demonstration: Wouldn't the mountain reflect in the lake? It would if it were far enough forward. If it's too far in the distance, however, light rays from the mountain won't get to the reflecting surface and bounce to meet this observer's eyes. Note that an observer placed much lower would see a reflection.

Harbor Hillside

Scenes like this are familiar to travelers in Greece or California or in a hundred other sunny places—a cluster of buildings hugging a hillside and almost spilling into the sea below. This is the sort of picture that allows you to let loose and pile objects helter-skelter on top of one another, ignoring the realities of architecture. The objective here is a happy impressionistic jumble of shapes and colors that capture the spirit of a place.

Brown built this collage using no reference materials except the images stored in his mind from earlier travels. You might wish to begin by finding a picture that inspires you—travel magazines, for example, are full of suggestive scenes.

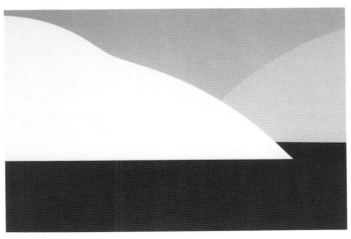

STEP I

Background

A dark blue construction paper does double duty as the backing and as the blue of the water. Then, working from back to front, use a medium blue paper for the sky and overlapping coral and pale gray papers for the hills—a bright palette for a sunny scene.

Materials

construction papers
- medium and dark yellow
- coral
- light, medium and dark blue
- brick red
- white
- black
- light green
- various shades of gray
- light violet

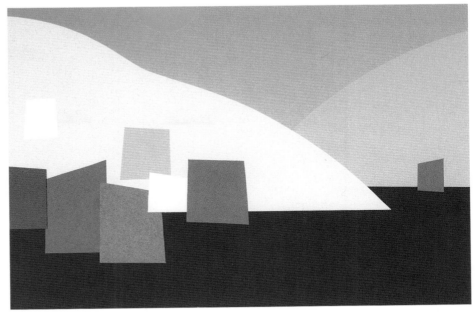

STEP 2

Experiment With Shapes

Cut some more or less rectangular shapes for a few buildings and move them around the surface until you're satisfied with their positions.

Brown adds a sun. On his first try, he tears a sun from a piece of paper, thinking that the torn edge might add a little vibrancy. He discards the torn sun in favor of a cut sun because he knows all the other edges in this picture will be cut, and the single torn edge might be a little out of place. For cutting circles, he uses a compass, a tool you may remember from school days. Instead of a pencil or pen in one leg of the compass, he uses a knife blade.

STEP 3

Have Fun

What's going on here? Some of the buildings seem to dip into the water! But why not? The collage process, Brown says, is childlike. It allows you to let loose and ignore reality.

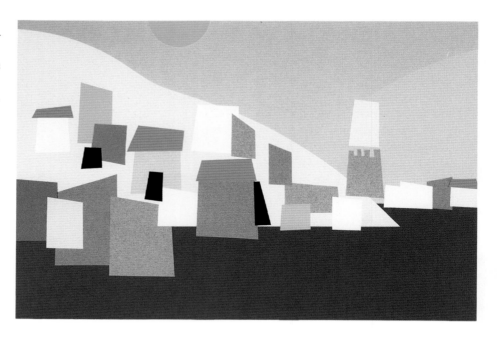

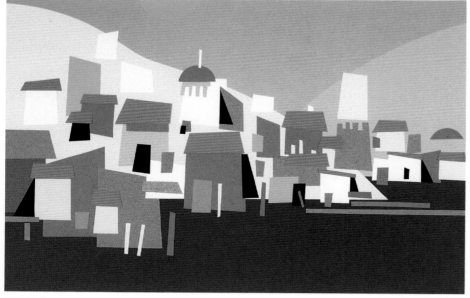

STEP 4

Add More Shapes

Continue to add shapes that complement those already laid down. It's important to break the uneventful curves of the background hills to make them more visually interesting, so allow some of the building shapes to break the hills' edges. Now add red tile roofs, which typify many such scenes. A few curved shapes offset the mostly rectangular buildings, and some strips begin to suggest pilings and docks.

Tacking

When you have many pieces to deal with and are not yet sure exactly where each will go, lightly tack them to the surface by spraying the backs with a little 3M Spray Mount. This allows you to remove the pieces of paper without tearing what's underneath or leaving a messy glue spot. Another product you may use is 3M Photo Mount, an adhesive intended for temporary tacking.

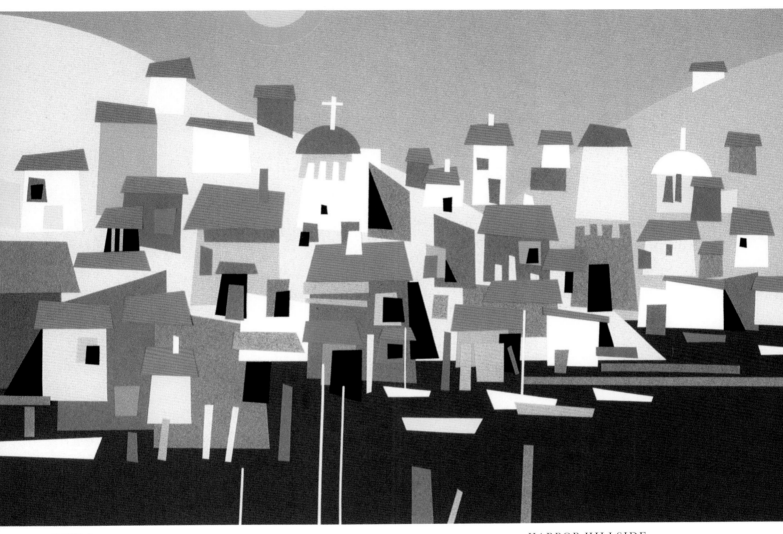

STEP 5

HARBOR HILLSIDE
12"×16" (30.5cm×40.6cm)

Details

Finish by adding building details, such as chimneys, windows, doorways and cast shadows, and then some boats, more pilings and a few boat masts. The boat shapes are simple, in keeping with other shapes in the collage. The single white boat at the left heads toward the right as a nice counterbalance to all the other boats that are heading left.

Notice elements that tie large areas of the picture together—for example, buildings that reach into the sky area keep the sky from feeling like an isolated piece of the picture. Also, the masts emerging from the bottom edge of the picture reach all the way to the cluster of buildings, thus helping to stitch together the water area and the building area.

Add a yellow inner circle to give the sun some extra glow, and finally, place a little building at the upper right on the distant hill to add a touch of distance.

Bull Durham Barn

Michael Brown loves old barns and often uses them in his paintings and collages. Although he admits to a nostalgia for times past that these barns represent, as an artist he's attracted by their varied shapes and colors and textures. Among his favorites are the barns whose sides are covered with advertisements, often for Bull Durham and Mail Pouch tobaccos. These bits of Americana are fading now, but you can still find them in rural scenes in the East.

In this demonstration, Brown uses his favorite technique for fastening the pieces down—the dry-mount press—but you may use any type of adhesive you wish.

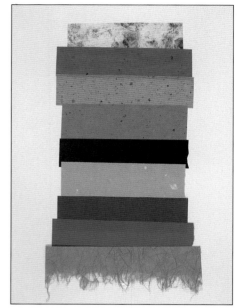

Here is Brown's "palette" for this collage, including at one end a fibrous blue paper for the foreground and at the other Mexican bark paper for the foundation. These or similar papers are available at larger art supply stores and through catalogs such as Daniel Smith, Dick Blick and Pearl.

STEP 1

Support and Background Shapes

The backing is Arches 300-lb. (640g/m²) cold-press watercolor paper, stiff enough to support the collaged paper without buckling or warping. Retain the attractive deckle edges of the paper rather than trim them—the finished collage may be framed with the deckle edges showing.

Center a piece of tan, textured paper over the backing. Next come the two rectangles of red paper for the basic barn siding, and then carefully cut black strips for the shadow areas. A blue-gray paper establishes the roof areas, and a strip of Mexican bark paper makes a lively foundation.

Materials

300-lb. (640g/m²) Arches cold-press
 watercolor paper

acrylic paints:
- white
- black
- yellow oxide

untextured papers
- black
- deep blue
- deep red

textured papers
- Mexican bark paper
- tan
- medium blue
- medium red
- blue-gray
- pink
- fibered blue

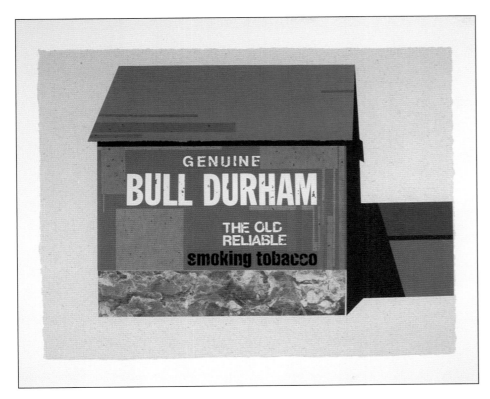

Lettering

The painted signage is important to this picture, so establish it next. Instead of doing the lettering directly on the face of the barn, build it on separate strips of red paper. If you're dissatisfied with the result, you can try again without messing up the barn face. Once you're happy with the lettering, fasten the entire strip to the barn face.

To make the lettering reasonably sharp edged, as it actually appears on barns, use cardboard stencils, painting through the stencils with thin white and black acrylic paint.

The final paper in this step is the light red door under "BULL."

Create Barn Side and Roof

Now carefully lay on strips of paper—grays, blues, reds—to suggest barn siding and roofing. Overlay or partially overlay one strip with another until you get the texture and color you want. Here and there, chip away at the lettering with the craft knife to begin giving the letters a weathered look.

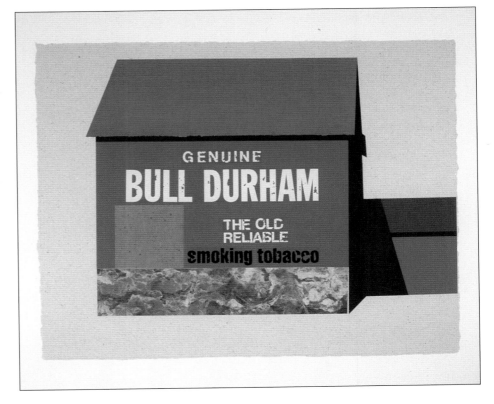

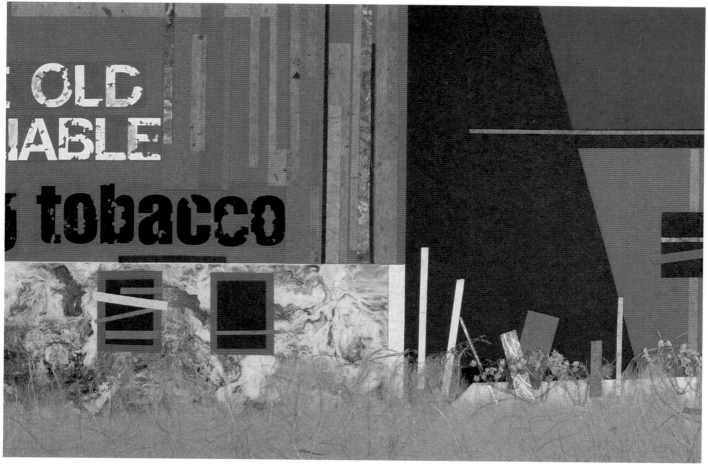

STEP 4

Create Mood With Details

Use a strip of fibrous paper for the grassy, weedy foreground. Brown chooses a blue paper. Why blue? He likes the way it goes with the blue roof. This is a good example of your license to do what feels right and ignore pure reality. Maybe this is Kentucky bluegrass!

Add more strips to the siding and concentrate on the foundation area. Look for places to effectively play contrasting values and colors against one another. Dark windows in a light wall are one example, and light fence posts against deep black shadow are another. Such contrasts give a picture spark and often add to the feeling of depth and mystery. The light horizontal edge of the right-hand roof breaks up the big, black cast shadow.

Age the lettering by dabbing at the white letters with some yellowish paint on a tissue. Lift flecks of both white and black letters from the picture by stabbing at the letters with a wad of masking tape and by chipping away with a craft knife blade.

smoothie

As Brown concentrates on cutting and gluing pieces, he muses on some of the differences between collaging and painting. In painting, you can often change your mind and paint over an area. In some collaging, you can certainly do the same, covering up areas with glued-on layers until you get what you want. But Brown's collages are generally flat surfaced and clean, with no appreciable build-up of materials, so covering up mistakes could result in an unsightly, lumpy picture surface. He usually prefers to keep the collage surface relatively smooth.

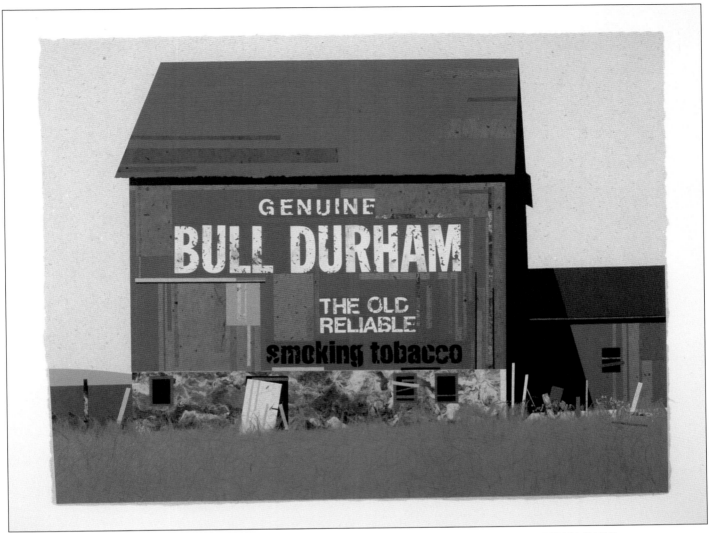

STEP 5

Finish

Something is needed at the left of the picture, so let's add a field and a distant hill. The
light blue of the hill instantly gives the picture depth.

Watercolor Mood

A collage may include any material you wish. Here we'll use paint for the background sky. It's a good way to set a mood for a collage. If you paint with watercolor, it helps to use watercolor paper or board as your support.

STEP 1

Watercolor Sky

Tape the edges of a sheet of 300-lb. (640g/m²) Arches watercolor paper to preserve a clean white border. Brush clear water over the upper two-thirds of the paper and brush into the wet paper mixtures of Indigo, Alizarin Crimson and Davy's Gray. Tilt the paper just enough to get the colors to run in a way that satisfies you. Use a hair dryer to speed up drying.

Materials

300-lb. (640g/m²) Arches-cold press
 watercolor paper
dried weeds
watercolor paints
• Alizarin Crimson
• Davy's Gray
• Indigo
acrylic paints
Rapidograph pen
papers
• black
• white
• light, medium, dark gray
• brown fibrous paper
• tan

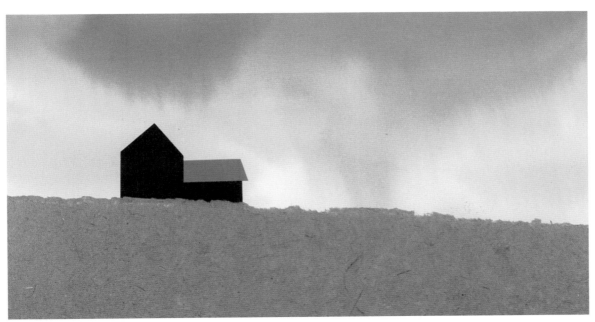

STEP 2

Build the House

The watercolor sky sets a quiet, solitary mood, so let's build a quiet, solitary house. You may build the house from light to dark or dark to light. Brown usually prefers to start with the dark, as he does here with pieces of black paper. Cut a gray roof for the right-hand part of the house, and use a brown, fibrous paper for the foreground field. The torn edge of the brown paper serves as a grassy, weedy hilltop against the sky.

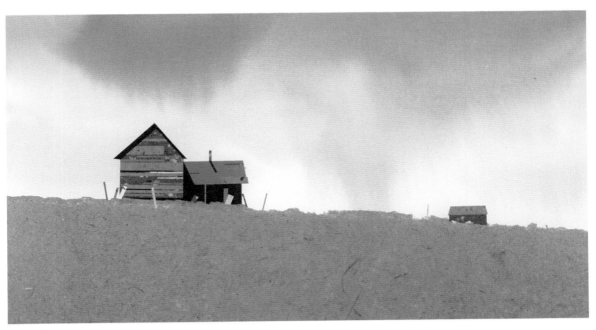

STEP 3

Experiment With Details

Now it's time for the detail work. Experiment with various colors and values for the pieces of paper making up the house siding. Too dark and you have no liveliness; too light and you lose the somber mood. Tack down each piece temporarily with a little 3M Spray Mount. When you're happy with a group of pieces, attach them permanently.

What about the shed added at the right of the picture? Inspiration? No. A thought-out bit of design? No. The shed is covering a flaw—some glue got onto the waxy papers used in the dry-mount process and showed up as a smudge in the sky area. Brown considered covering the spot with grasses or trees, but they didn't fit the stark mood. He decided on a shed—a happy choice, since it looks as though it was part of the original design. If the smudge had shown up higher in the sky, Brown would have junked the picture and started over.

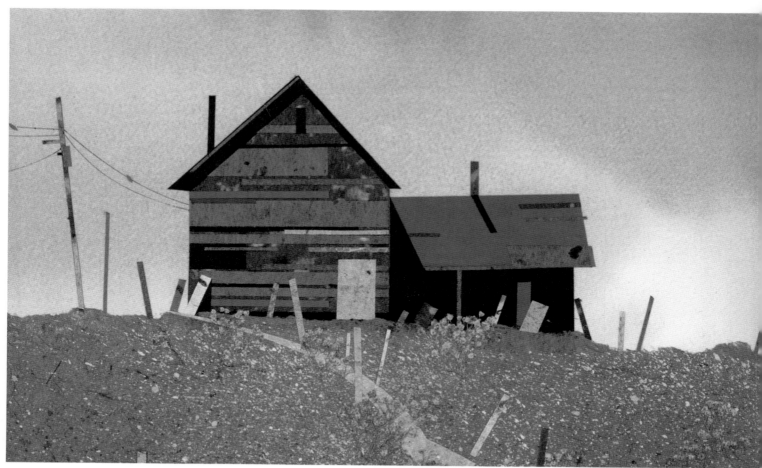

Detail

The path is a piece of paper. Some of the weeds are actual dried weeds, flattened and glued in place with a bit of acrylic gel medium; others are white and reddish acrylic paint spattered with a toothbrush.

Spatter Neatly

When spattering one area of your picture with paint, be sure to cover the rest. You probably don't want weeds growing in your sky.

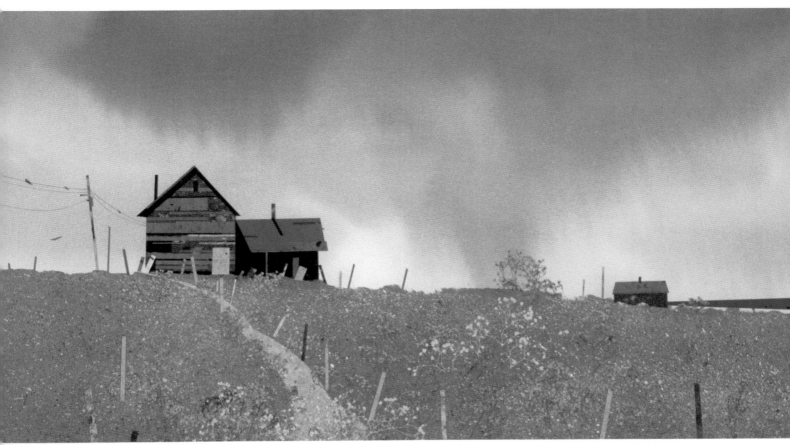

STEP 4

Take Time With Details

The early stages of this collage went fast, but the details, simple though they may appear, took hours to complete. Time is spent not so much in cutting and pasting as in cutting and trying and looking and thinking and trying again. For example, Brown tried several times to cut thin enough strips of paper to represent the electric lines, but they were too fine to glue down with any assurance that they wouldn't pop off if the picture were flexed the least bit. He then considered painting the lines with a thin watercolor brush. He finally chose one of his favorite instruments, a fine-point Rapidograph pen, to draw the electric lines.

The electric pole at the left was at first a single dark strip of paper. Brown felt the dark needed to be modified, so he added bits of lighter paper for variety. Finally, he added tiny bits of paper for birds and strips of white and blue for the distant water.

WATERCOLOR MOOD
17″×30″ (43.2cm×76.2cm)

Perspective Pointers

ONE-POINT LINEAR PERSPECTIVE

Linear perspective is the use of converging lines to suggest depth in a picture. The points at which lines converge are called *vanishing points*. Some pictures have a single vanishing point and others have two or more. A picture with a single vanishing point is said to be done in one-point perspective.

If you are viewing the outside of a rectangular object, such as a box or a house, in one-point perspective, you see nothing of the sides of the object. You see only the front and possibly the top or bottom. The horizontal edges of the object that are perpendicular to the picture's surface seem to converge as they extend into the distance. The point where these lines converge, the vanishing point, lies on a line called the *horizon*. The horizon is simply a line representing the eye level of a viewer standing and looking straight ahead. *Eye level* and *horizon* in this context are synonymous.

A box in one-point perspective below eye level.

A room interior in one-point perspective. All receding horizontal lines, such as floorboards, top of doorway and ceiling edges, meet at the vanishing point.

Pictures in one-point perspective are often symmetrical and formal. Many well-known paintings, such as Leonardo da Vinci's *The Last Supper*, use one-point perspective.

TWO-POINT LINEAR PERSPECTIVE

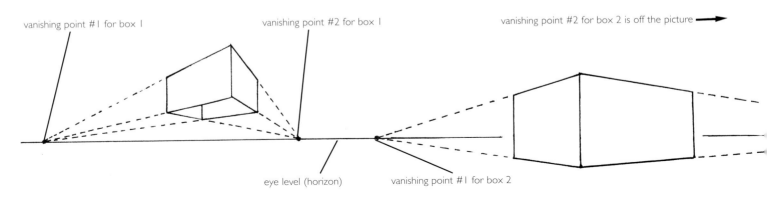

vanishing point #1 for box 1

vanishing point #2 for box 1

vanishing point #2 for box 2 is off the picture ➡

eye level (horizon)

vanishing point #1 for box 2

In two-point perspective, you see more than just one face of an object. Here are boxes in two-point perspective. The receding horizontal edges of one side of each box meet at vanishing point #1, while the edges of the other side meet at vanishing point #2. Notice that each box has its own pair of vanishing points, all on the same eye level, or horizon. Depending on an object's position, one or both of its vanishing points may lie far from the box (and off your picture). But all receding horizontal lines, if extended far enough, meet at one vanishing point or the other.

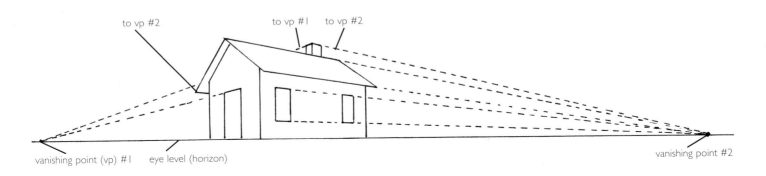

to vp #2

to vp #1 to vp #2

vanishing point (vp) #1 eye level (horizon)

vanishing point #2

Now suppose you have, instead of boxes, a building in two-point perspective with window, chimney and door. For a normal, rectangular building, every receding horizontal line follows the same rules as the lines of the simple boxes above. Once you've established two vanishing points, all you need to do to get the right slope on chimney tops, window frames, siding, etc., is draw lines to the appropriate vanishing points. Position vanishing points wherever you please, as long as they're on the horizon (eye level) line. Experiment to see the effects of shifting one or both vanishing points. The closer together the two points are, the more distorted your building will look; the farther apart they are, the flatter your building will be.

* For more perspective, see North Light's *Perspective Without Pain*.

Moonlit Harbor

Brown knew only that he wanted to do a nighttime scene. He painted the dark sky first, and only then did he decide on what sort of scene he would place in front of that sky. He considered a desert locale at first, but he eventually decided on a harbor motif.

Materials

300-lb. (640g/m²) Arches cold-press watercolor paper

acrylic paints
- Cadmium Red Deep
- Cobalt Blue
- Maroon
- Brilliant Purple
- Titanium White
- Alizarin Crimson

untextured papers
- black
- dark and medium blue
- white

textured papers
- thin white (moon)
- white and off-white
- light, medium and dark gray
- light, medium and dark blue
- medium red
- light red
- pink
- blue-green
- brown
- Mexican bark

STEP 1

Sketch

Although this is a pretty minimal sketch, it establishes intent: There will be a moon; there will be boats on water; and the buildings will be rendered in two-point perspective.

STEP 2

Set the Stage

Paint the background on 300-lb. (640g/m²) Arches cold-press watercolor paper using acrylic paint. Mask off the edges, then wet the paper with clear water and paint the acrylic into the wet paper. Blend colors as you go. Grade the color from a dark red-black at the top to a lighter blue-violet near the horizon. You might, of course, paint the entire sky one flat color, but in this picture the sky is large, and large spaces usually need color variation if they are to be interesting. The mixture of colors also gives the sky a satisfying glow.

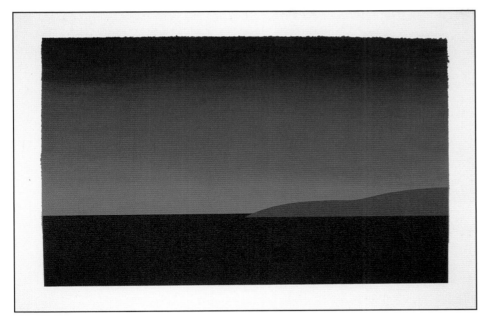

STEP 3

Create Depth With Shapes

Remove the protective drafting tape from the picture's edges and lay down a strip of black paper for the water area on the lower third of the picture. You might use other dark colors, but black seems satisfying and dramatic. Cut a dark blue strip of paper for a distant finger of land and quickly the picture takes on some sense of depth.

Have Fun!

Brown's overall approach to drawing, painting and collaging obeys the laws of technical correctness just enough to make the picture believable, but he refuses to be so fussy that the picture becomes anywhere near photographically correct. His style allows for lots of play and plenty of artistic license. "Hey!" he says as he glues down a piece of paper that slightly violates the law, "You gotta have fun at this, or why do it?"

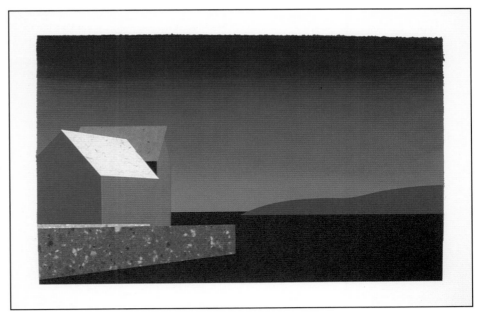

STEP 4

Place Structures

Begin the structures with a piece of textured paper for the wharf and then blue, gray and red papers for the basic building. Cut a lighter gray paper for the moonlit roof and another gray for the narrow strip on the upper surface of the wharf. The order of placement is (1) red siding, (2) dark gray roof, (3) dark blue end of building, (4) light gray roof. This order allows shapes to be progressively overlapped and minimizes cutting around shapes.

This collage involves the use of two-point linear perspective. In such a scene, buildings may be viewed at an angle. See pages 64-65 for more on linear perspective.

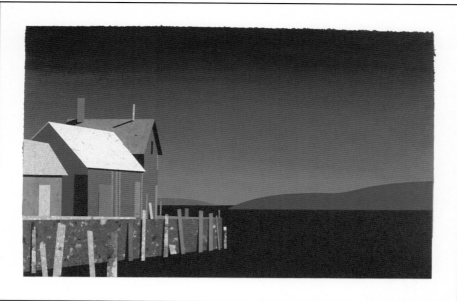

Value Added

Notice the pleasing glow that results where the dark strips of water and land are laid next to the somewhat lighter sky. There is probably no more effective way to make a light- or medium-value color sing than to put an intensely dark value next to it.

STEP 5

Details

Begin detailing. Add pilings, chimneys, a smaller bit of land in the distance for more depth, and so on. Give the roof of the leftmost building a pitch different from that of the larger building just for variety. Don't line up too many items, such as window openings or fence posts or pilings. Things arranged in neat rows can be boring.

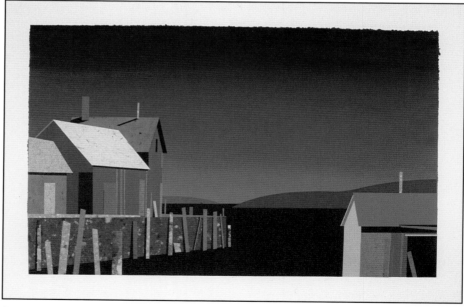

STEP 6

Balance the Design

Now the right-hand corner needs attention. Brown tries a number of boat shapes in that area but they all seem to let the eye wander down and out of the bottom of the picture. After considerable time and thought, he decides he needs the solidity of a building to close off the corner of the picture and force the eye up into the scene. He turns the building slightly toward the viewer so that you see a light, moonlit side. This nicely repeats the lightness of the moonlit roof at the left. Like the first buildings, this one is shown in two-point perspective. He places the building just below the background hill so as to leave the curve of the hill intact.

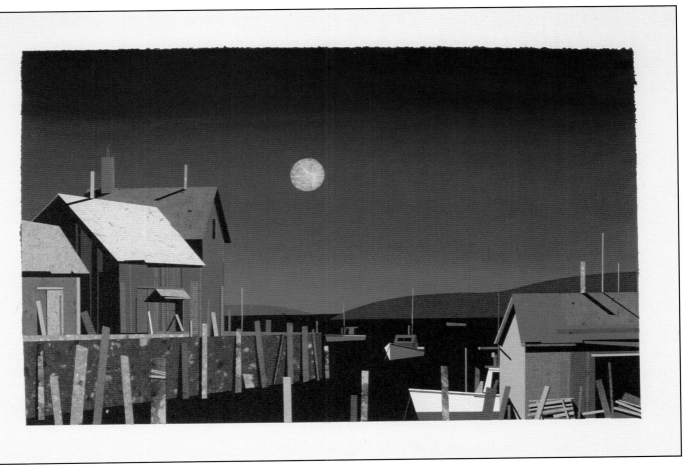

STEP 7

MOONLIT HARBOR
16" × 25" (40.6cm × 63.5cm)

Final Details

Brown finishes with details that look simple but require lots of time and patience. The entire collage took about twelve hours to complete; final details (boats, lobster traps, clutter, shadows) took around four hours. Seemingly simple elements, such as distant boat masts or antennas, took several tries to get their values right: If too dark they got lost in the background; too light and they jumped forward.

In realistic work such as this, some consistency is important. Once you've established a single light source (such as this moon) you'll want to make cast shadows fall in roughly the proper directions, away from the light source. Beyond that, physical correctness takes a backseat to doing what feels right for the picture.

The Colors of Night

A night scene is not simply a daytime scene with a black veil drawn over it. Given a bright moon or other nighttime lighting, colors are strong and vibrant and shadows are sharp.

Sunflowers and Quilts

No matter how vivid a memory you may carry about a subject, you may often need to look at reference photographs and sketches or visit a site to give your memory some nourishment. Here are a few of the references Michael Brown used for this collage.

STEP I

Sketch

Start with a rough sketch, keeping in mind you may change it later. This was Brown's initial design—sunflowers to the left, quilts at the right against the building.

Materials

300-lb. (640g/m²) Arches cold-press
 watercolor paper
dried weeds

acrylic paints
- Cobalt Blue
- Titanium White

untextured papers
- black
- deep blue
- brown
- medium red

textured papers
- white
- thin white
- light green-gray
- light green
- medium green
- dark green
- tan
- light brown
- dark brown
- purple
- pink
- yellow
- medium red
- blue-green
- Mexican bark

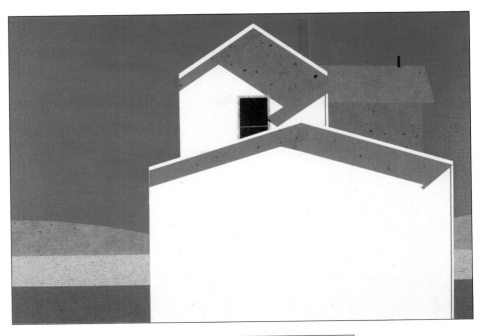

STEP 2

Begin With the Sky

Use Arches 300-lb. (640g/m²) cold-press watercolor paper for the support, and work from back to front. Lay in the sky with a mixture of Cobalt Blue and Titanium White acrylic paint. Use colored papers with varying textures for the building and the strips of land.

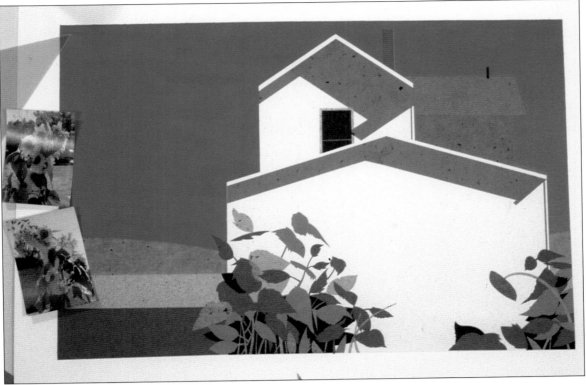

STEP 3

Welcome Second Thoughts

Begin at the house corners, cutting and trying leaf shapes from a variety of green textured papers as well as some black paper. The black behind the greens helps give the greens more impact. Move the leaf shapes around to find a pattern that pleases you before tacking them down.

Thinking the quilts might be too bright and overpowering against the light building, Brown reversed their original placement with the sunflowers.

Here you can see what Brown's work space looks like. Lying around the picture are: a can of 3M Spray Mount; a plastic triangle, used both as a straightedge and for squaring up edges; pieces of papers from which he has begun cutting leaf shapes; reference photos; an X-Acto knife and scissors.

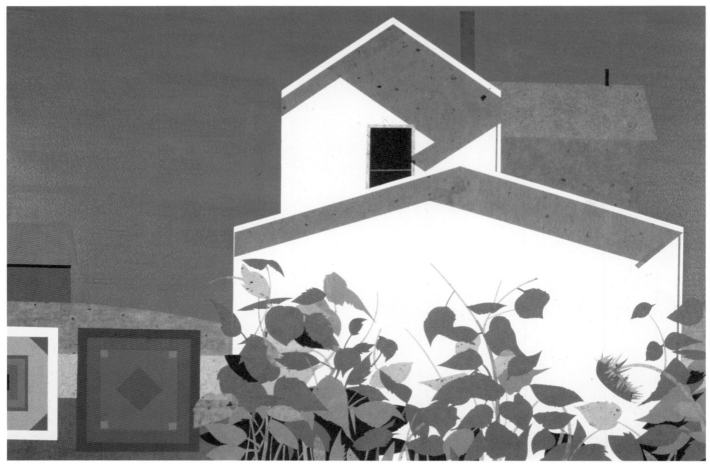

STEP 4

How Does Your Garden Grow?

Cut individual leaves and stalks and position them across the face of the building, overlapping them for a three-dimensional effect. Add the building in the distance to give the picture more depth and at the same time echo the shapes and colors of the upper right of the main building.

Time to sew the quilts! Work from back to front and overlay flat shapes on flat shapes. Brown didn't piece together individual sections in mosaic fashion, as a quilter would—such an exercise might have been interesting, but there is one's sanity to consider!

Get Out of the House

There is no substitute for getting out as often as possible and really seeing what you intend to paint or draw or collage. You can work for a while based on images in your memory and photographs you've gathered, but you've got to refresh your memory and recharge your ideas by getting out on-site as often as possible.

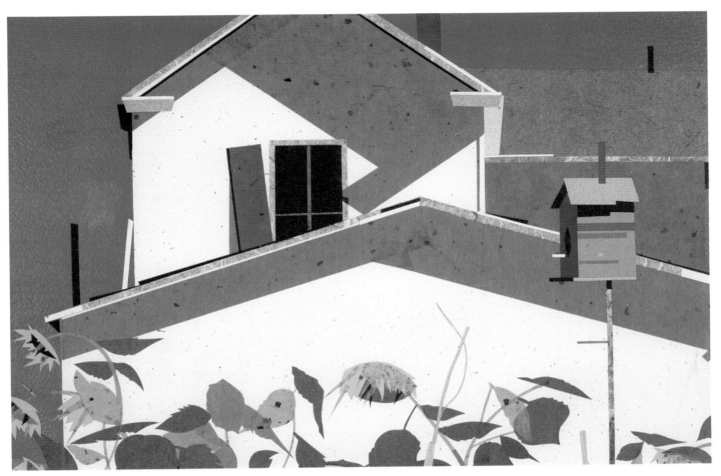

STEP 5

Little Touches Add Life

Add detail to the buildings to give them life—overhangs, shadows, the edges of shingles. An off-kilter shutter relieves the symmetry of the building's upper face.

Brown questioned the placement of the little black vent pipe in the right-hand roof—should it cast a shadow, and if so, in what direction? He used a flashlight to answer the question (see page 75).

STEP 6

Continue to Add Details

The sunflowers and weeds take on a life of their own and grow along the bottom of the collage. Add fence posts, one of Brown's favorite foils. Notice that the posts in front of the quilts help to push the quilts a little farther back. Any time you place object A in front of object B, the effect is to make object B seem farther back.

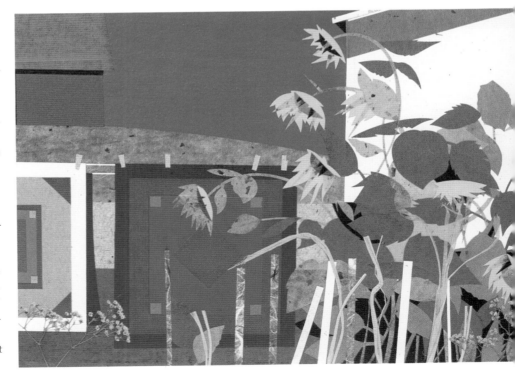

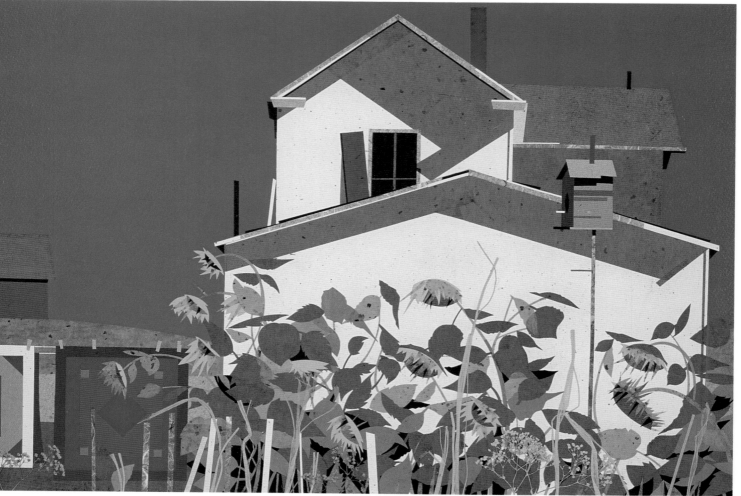

STEP 7

SUNFLOWERS AND QUILTS
17"×25" (43.2cm×63.5cm)

Weeds Are the Final Touch

The bunches of weeds across the foreground are not easy to fasten in place since they are real weeds, frilly and thin and difficult to handle. Ease the problem by first compressing the bunches of weeds in a dry-mount press without heat. Once flattened, the weeds are easier to handle. You can get the same result by squeezing such objects in any vise or between the pages of a book. If the weeds are crumbly, dampen them before trying to flatten them to keep them from falling apart.

(If you are building a collage that is three-dimensional, you don't need to flatten anything, but you'll need to frame the finished piece in some sort of deep frame. See chapter two.)

stay sharp!

While cutting numerous small shapes, replace craft knife blades at the first sign of dullness.

Shadow Pointers

In *Sunflowers and Quilts*, as in other pictures, there are shadows to contend with. If you're doing realistic work, you'll want your shadows to look reasonable. But often it's difficult to figure out where a shadow ought to fall if you've decided to move the light source around. When in doubt, set up some objects similar to those in your picture, shine a flashlight on them and see how the shadows behave.

This is easy to do. Suppose you want to discover how a shadow of a round chimney or vent pipe will look on a slanted roof. All you need are a flashlight and a cardboard roof with a pencil stuck through it. Lower the room light to see your cast shadows more clearly.

Or suppose you want to see how shadows would fall on and around a building. Make a building out of scraps (this only takes a few minutes) and shine a light on it. As you move the light source, you'll find shadows forming that you might never have guessed. For more about shadows see North Light's *Enliven Your Paintings With Light*.

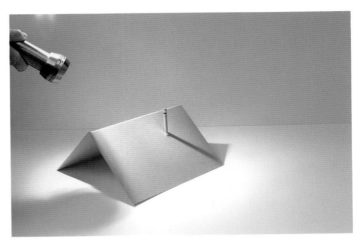

Move the light source (the sun) around and . . .

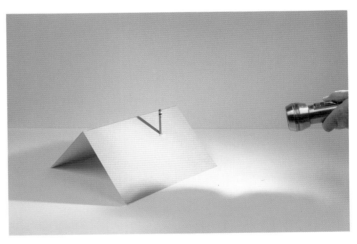

. . . see how the shadows change.

Cast shadows on a house.

A Winter Tree

Whether you're painting a tree or building one out of papers, it's important to pay attention to how a tree is structured. If you depict every branch coming laterally from the right and left sides of the tree, it will look flat. But if you keep an eye on how branches join the trunk on the side facing you, you'll be able to make some branches come forward so your tree will have a three-dimensional quality.

Materials

300-lb. (640g/m²) Arches cold-press
 watercolor paper

acrylic paints
- Neutral Gray
- Titanium White

textured papers
- medium blue-gray
- dark blue-gray
- solid white (snow on branches)
- speckled white (foreground snow)
- Mexican bark paper, light and dark

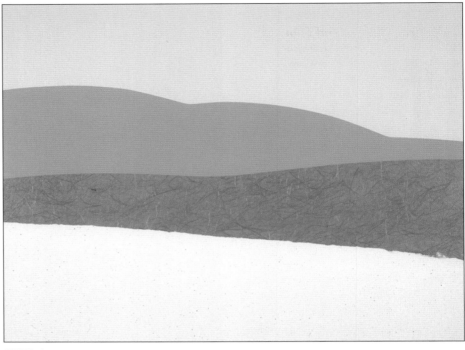

STEP 1

Set the Stage

The setting for this tree collage is a five-layer background put down in the following order:

Support: 300-lb. (640g/m²) Arches water-color paper

Sky: Neutral Gray acrylic paint
Distant hill: gray paper
Nearer hill: textured gray paper
Snowy foreground: speckled white paper

STEP 2

Building Your Tree

Begin the tree with bark paper, made in Mexico from the bark of indigenous trees. It comes in several varieties (the *Daniel Smith* and *Dick Blick* catalogs currently list up to six), and these papers are acid-free. Their beautiful patterns and colors vary from batch to batch. Here we use two shades. Concentrate on the trunk and main branches before getting into the smaller branches and twigs.

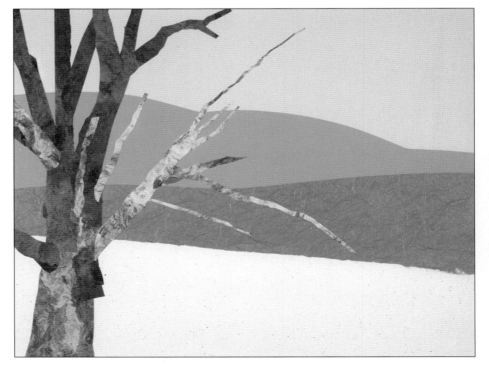

STEP 3

Add More Branches and Snow

Continue to grow the tree, using some of the lighter bark paper and some white paper for snow patches.

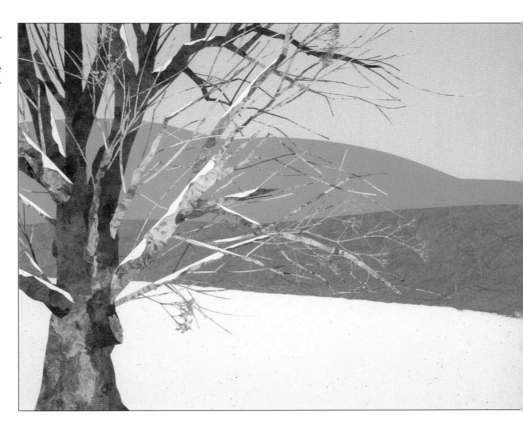

STEP 4

Almost There With Stream and Building

Add a stream, using a strip of blue-gray paper. The little building at the right is just enough to balance the mass of the tree at the left. Make the side of the building from the same bark paper used on the tree. At this stage, you could easily settle for this as a finished picture.

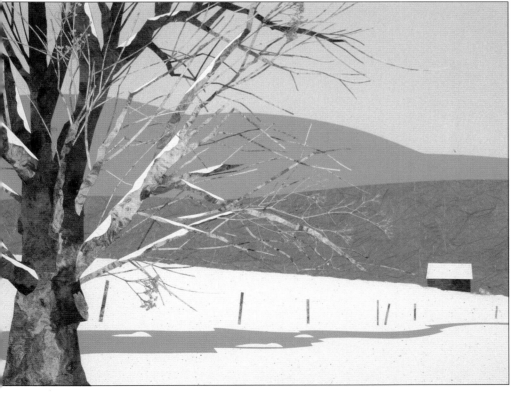

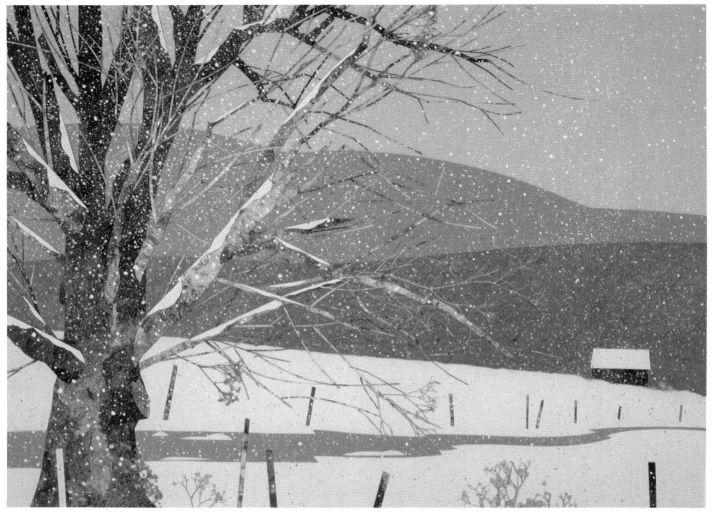

STEP 5

Quiet Snowfall Completes the Picture

Add falling snow by spattering acrylic paint from a toothbrush. Take your time and don't overdo it—you can always add more snow, but you can't remove it once it's dried. A few more foreground details and you're finished.

A WINTER TREE
13½″ × 18″ (34.3cm × 45.7cm)

Getting Cute

Before finishing this picture Brown tried a couple of additions—a red cardinal in the tree, a yellow light in the building. Although they would be perfectly acceptable, he decided they're too sweet and eliminated them. He talks about one of the reasons artists sometimes add things to their pictures that make them feel uncomfortable—sales! Would a little red bird make the picture more salable? Probably. But out it goes!

Farmland

M ichael Brown loves rolling farm-
lands, which often look like a mo-
saic of colored and textured stripes. He
decided to exaggerate color in this
collage.

Materials

300-lb. (640g/m²) Arches cold-press
 watercolor paper

acrylic paints
• Titanium White
• Alizarin Crimson

untextured papers
• black
• white

textured papers
• medium and dark green
• light, medium and dark blue
• yellow
• violet
• brown
• white
• light gray

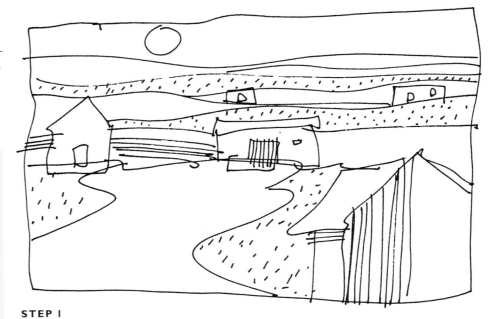

STEP 1

Sketch for **Farmland**

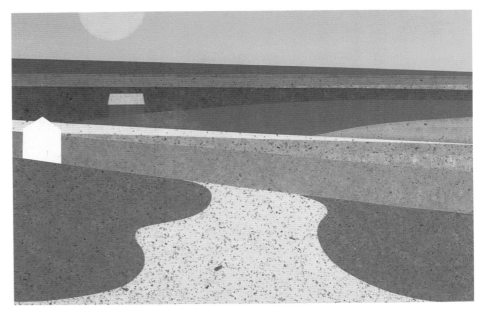

STEP 2

Farmland *Foundation*

With 300-lb. (640g/m²) Arches watercolor paper as the background, paint the sky with
Titanium White and Alizarin Crimson acrylics and work forward, laying down strips of
textured papers. The sun is a piece of thin white paper.

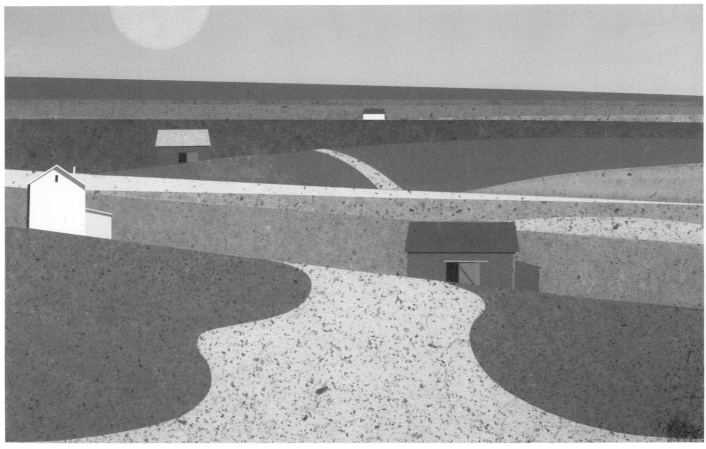

STEP 3

Buildings Recede for Depth

Put in buildings of different shapes, their sizes diminishing as you place them farther back in the picture.

Keep the Surface Clean

When you're satisfied with the position of a small piece of the collage, turn the piece over onto a sheet of newspaper and spray its back with adhesive. Use the point of the craft knife to pick up the piece and carry it to the collage. Don't pat a piece of paper down using dirty or sticky fingers—a bit of adhesive on the surface can ruin the look of a piece. Sometimes it's useful to press pieces in place by covering them with a sheet of clean tracing paper so your fingers don't touch the collage.

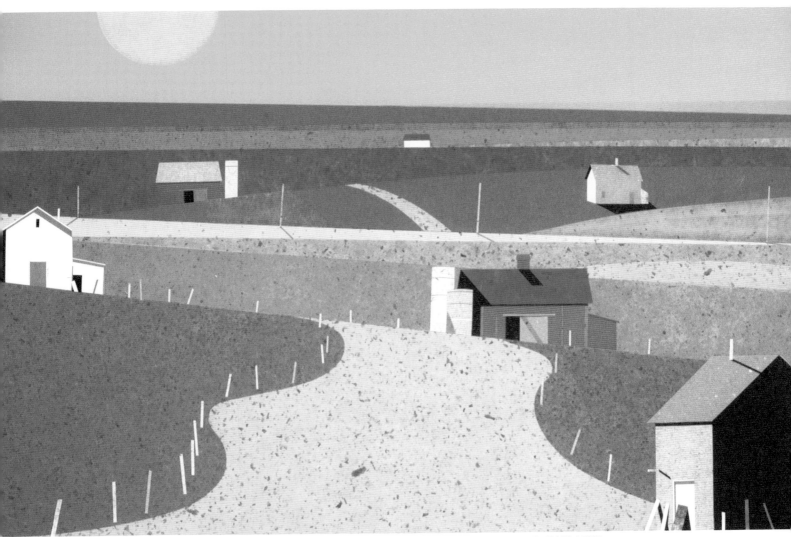

STEP 4

Final Details

Add silos, doors and windows, fence posts, poles, and so on. At the upper right, a faint, purple hill line adds to the sense of distance.

FARMLAND
18″×27″ (45.7cm×68.6cm)

City Streets

This complex collage offers a visual feast for the artist. When trying to capture the wear and clutter of an older part of town, it's tough to pick and choose which elements to include in the picture. Brown took these Polaroid photos in Baltimore and Washington, DC, to use for reference.

Materials

140-lb. (300g/m²) Arches cold-press
 watercolor paper
300-lb. (640g/m²) Arches cold-press
 watercolor paper
watercolor paints (variety)
aluminum screen for fence
cloth
magazine clippings
Rapidograph pen

acrylic paints
• Deep Violet
• Alizarin Crimson
• Neutral Gray
• Titanium White

untextured papers
• black
• deep blue
• deep blue-gray

textured papers
• tan
• light brown
• medium brown
• light and medium red
• medium blue
• medium gray
• light gray
• white (thin)
• light and medium yellow
• pink
• purple

Sketch

This is the sketch Brown started with. We may expect lots of changes before we get to the end.

STEP 2

Background Color

Tape off two inches all around a piece of Arches 300-lb. (640g/m²) cold-press watercolor paper. Wet the paper with clear water and then rapidly brush on mixtures of acrylic colors: Deep Violet, Alizarin Crimson, Neutral Gray and Titanium White. Scrub around with both a brush and a painting knife to get a color mix and texture you like. Brown wants a color that will set a somewhat surreal mood for the picture.

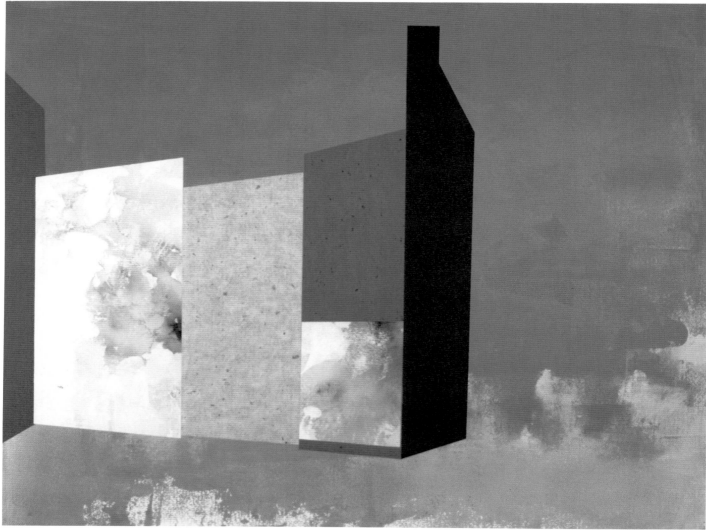

STEP 3

Start Your Buildings

Begin with large pieces of paper for the faces of buildings. Look for combinations of colors that play well against each other and against the background sky. The two lightest papers are 140-lb. (300g/m²) watercolor paper painted randomly with watercolor paint and Titanium White acrylic. Cut shapes to suggest exaggerated perspective.

Use a black shape to turn the corner. Here the use of light and shadow has established the light source (the sun) somewhere to the left.

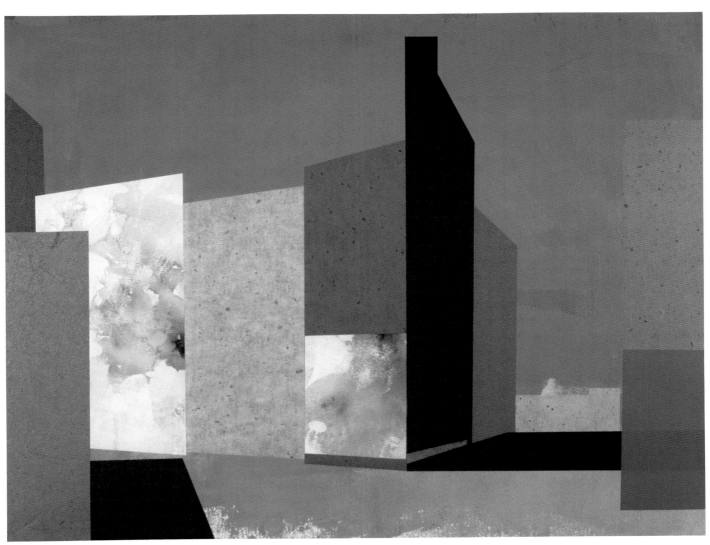

STEP 4

Experiment With Shadows and Perspective

Begin the building at the right, twisting it so that its perspective is different from those at the left. Add the beginning of a building at the far left along with a piece of cast shadow. Use deep black for dramatic shadows. Indicate a sunlit building at the far end of the street to pull the eye down that street and suggest distance.

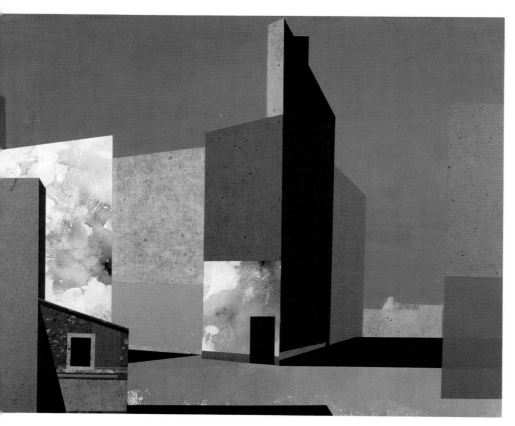

STEP 5

Begin to Flesh It Out

Now it's time to start detailing. Brown decided he didn't like the cast shadow at the left and covered it with a shedlike addition to the brown building. Like a painter, you can cover an area with something you like better. This works as long as there is not an unsightly buildup of paper.

STEP 6

Details

More detail up front and down the street in the distance.

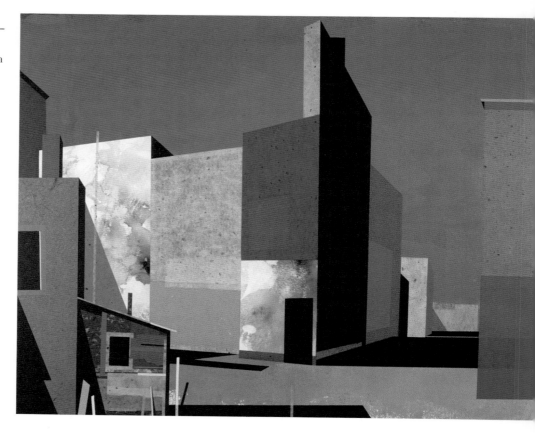

STEP 7

Details

Add roof cornices, some interesting patch-work on the buildings, the beginnings of some chimneys and a couple of awnings.

STEP 8

And More Details

A pole in the foreground may become a light pole; a sidewalk runs around the right-hand building; a trash can sits in the left corner. The window at the extreme left is made by putting down a piece of light paper first, then black on top of it (rather than the more tedious way—putting down the dark first and then cutting light strips to surround it).

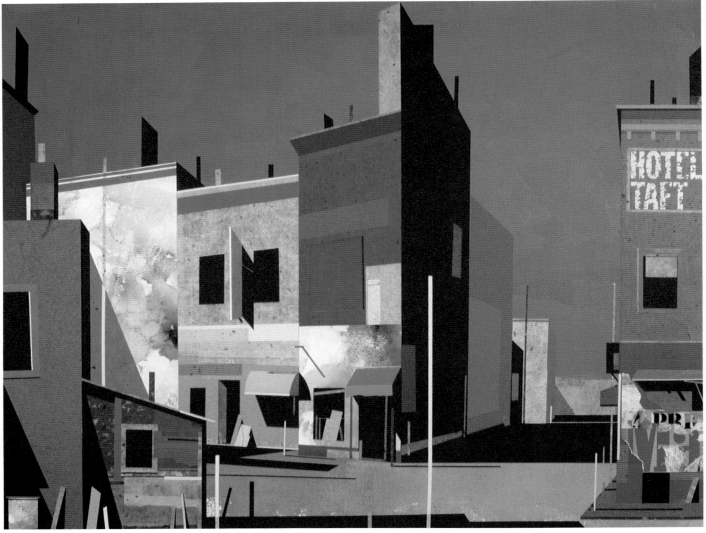

STEP 9

Graffiti

Make the hotel sign by laying down letter stencils and painting with white acrylic. For the lower wall tear out a piece of a magazine page. Magazine pages are not as permanent as some other papers and colors, and this part of the collage may, over a long time, begin to fade a bit. However, since this bit of magazine represents graffiti, it won't matter that it ages—graffiti ages too!

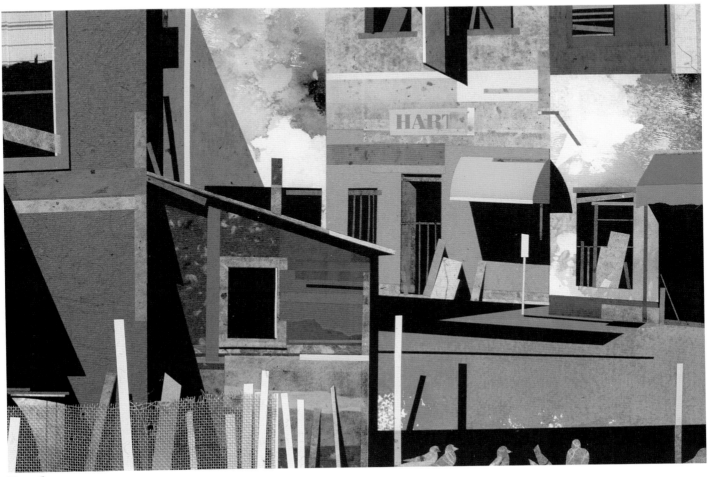

Detail

The fence at the lower left is made from a strip of aluminum screening held down by acrylic gel medium. For a little extra fastening, Brown laid a couple of strips of paper *over* the screening and glued them down, as usual, in the dry-mount press.

Detail

Here's a look down the side street. You get a sense of distance because the buildings diminish in size. The blue hotel sign around the corner is a nice color relief from the surrounding warm colors. Draw in the electric lines with a Rapidograph pen. Brown mulled over for a while how many lines there should be, and, as usual, put in just enough to satisfy the picture, remarking, "I don't care what the phone company thinks!"

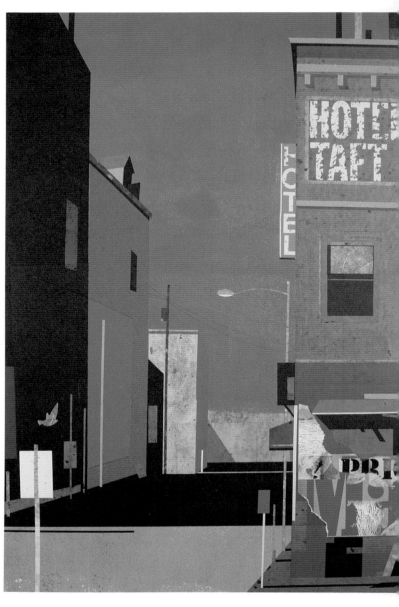

Detail

Here are some boarded windows and a pair of awnings, one curved and the other not, for variety. The gray strip on the sign at the lower right tells you this is the back of the sign.

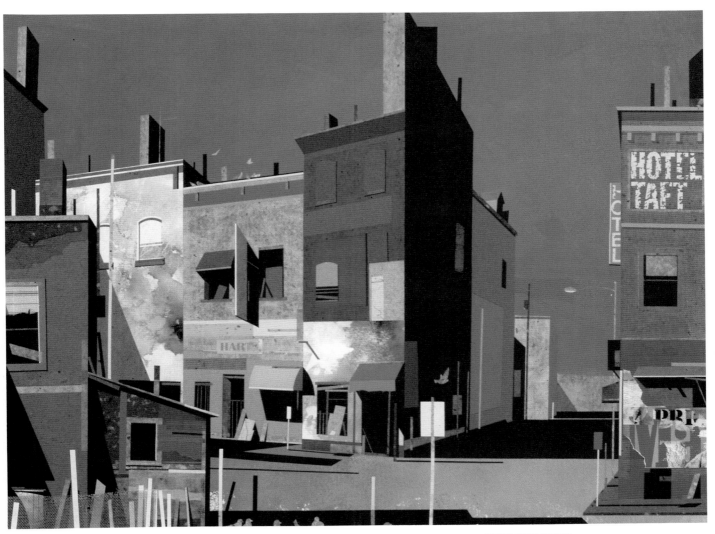

STEP 10

CITY STREETS
25″×32″ (63.5cm×81.3cm)

Finishing Touches

Add little touches all over the collage—sunlit faces on the chimneys, a bit of cloth for a window curtain, a piece of aluminum screen for a fence. For visual interest you may have some windows recede and others project out from the building. Notice that the high pole that was to be a light pole in the right foreground is now a sign. Brown had to remove the top part of the pole and tore up some of the black paper beneath it, so he cut a new piece of black to cover the damaged area. He also altered a sign projecting from the left-hand buildings to put it in proper perspective.

Realism From Abstract Materials

A DEMONSTRATION BY ROBERT KILVERT

Robert Kilvert of Weobley, England, shows how he achieves startling realism through the use of materials from the color supplements of his daily newspaper.

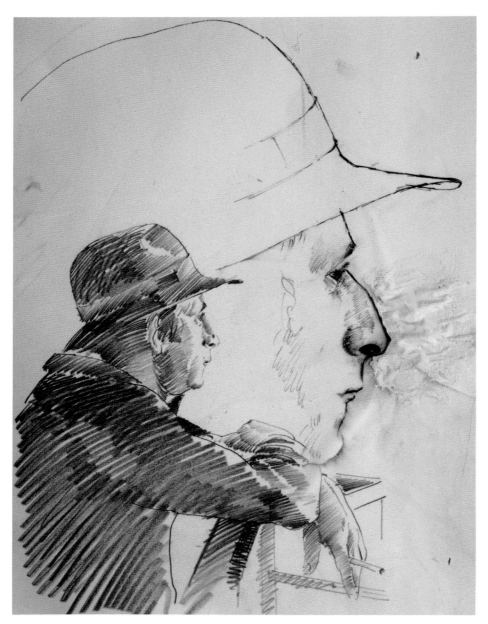

STEP I

Start With a Sketch Overlay

Kilvert makes a drawing on a sheet of clear acetate. He flips the drawing down over the developing collage to help him define edges and main shadow areas. Once those are established he will discard the overlay.

STEP 2

Establish Color and Form

Here are some initial color pieces in place, overlaid with the drawing. Sections from a bottle in an advertisement begin to suggest the hat, and the profile of the nose is represented by the slender arm of a girl.

STEP 3

Keep It Vital

"Now," says Kilvert, "the collage has advanced to the 'blocking-in' stage, and the subject looks like a character from a space drama! Working from static reference instead of a live model there is always the danger of the portrait lacking vitality, so I shall compensate for this by showing the face in strong light and shadow."

STEP 4

Light Your Subject

Kilvert adds light on the face and begins thinking about a window—some source for the light.

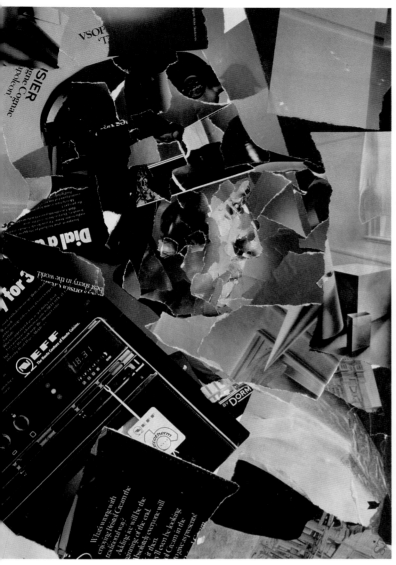

STEP 5

Model the Features

He models the face with cuttings of suitable colors. The effect, he feels, is similar to that of an oil painting. But he fears the subject "looks as if he may be driving a tank! His hat is not unlike a steel helmet!"

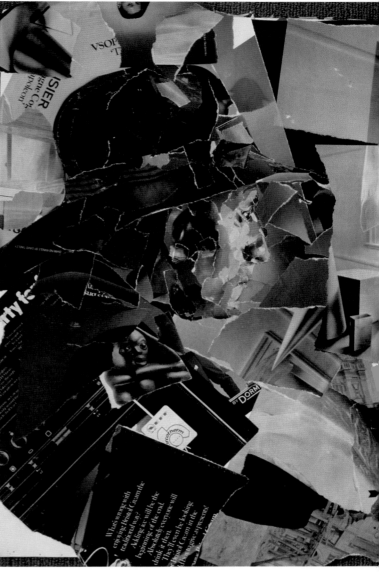

STEP 6

Environmental Elements

Kilvert has softened the hat and is now considering what to do with the background and how to provide a light source.

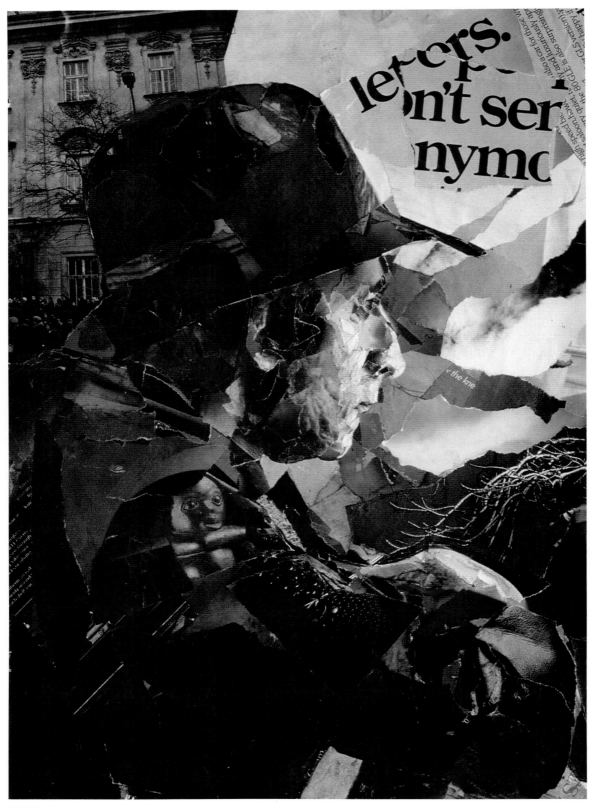

STEP 7

Determine the Setting

He decides the building at the upper left suggests an urban setting which helps explain the man's clothes. The building, along with the figure, creates a satisfying L-shaped composition. The upper-right window space becomes the source of light falling on the figure. Kilvert considers the lettering within it as perhaps fashionable but unrelated, so it will have to go.

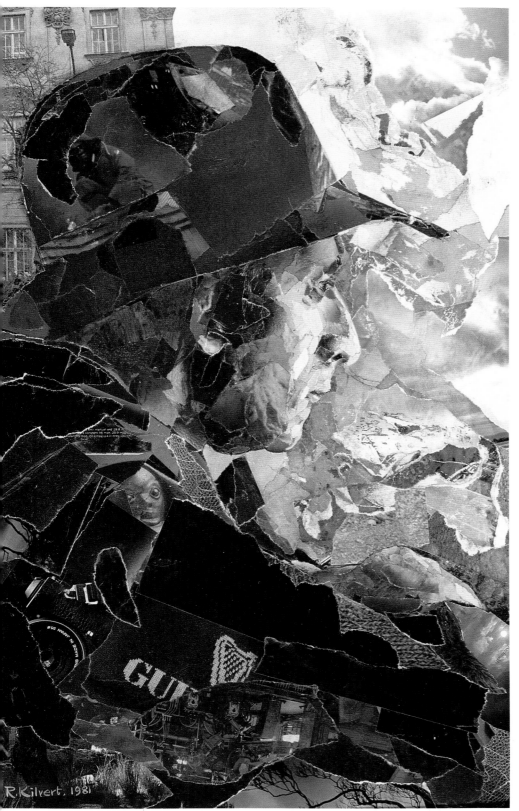

THE BLACK FELT HAT
22″ × 15″ (55.9cm × 38.1cm)

Final Details

He fills the window area with cool light to complement the warm portrait. Here Kilvert says, "I have torn through the existing material and added more to create a light effect which could be seen as sky, a snowscape or possibly a mountainside."

The Lisle Letters

EDITED BY Muriel St. Clare Byrne

Selected and Arranged by Bridget Boland

Foreword by Hugh Trevor-Roper

Book Cover
The publisher gave Brown a synopsis
of a book to be called *Lisle Letters*, and
Brown designed this cover (see facing
page). This is an all-paper collage, in-
cluding some pieces from magazine
photos and some press-on dots for the
beads.

chapter four
Gallery I

MICHAEL DAVID BROWN ILLUSTRATIONS

Here is a sampling of Michael Brown's work, includ-
ing both fine art collages and those done for com-
mercial clients. The commercial pieces are but a
small sampling of the thousands of such pieces he
did. After a long career involving commercial illustra-
tion, Brown shifted gears and began doing fine art
collage not dependent on a corporate customer's
needs. Many of the methods and materials remain
the same, but, as you'll see, the commercial collages
are different in tenor from the fine art collages
shown here and elsewhere in this book.

Commercial Art Collage

Magazine Article

This appeared in an article about Disney's Michael Eisner in *Playboy* magazine. It includes photographs (that's Eisner in the center) as well as photocopies of money that Brown tinted with dyes and markers.

R I B I T

Frog went a-court-in'
and he did ride, M-hm,
Frog went a-court-in'
and he did ride, M-hm'
Frog went a-court-in'
and he did ride,
Sword and pistol
by his side, M-hm.
Rode right up to
Miss Mouse's door,
Gave three raps and
a very loud roar, M-hm.
Said he, "Miss Mouse,
are you within?"
"Yes, kind sir,
I sit and spin, M-hm."
He took Miss Mousie
on his knee,
Said, "Miss Mouse
will you marry me?"
M-hm.

"Without my Uncle
Rat's consent,
I wouldn't marry
the President, M-hm."
Uncle Rat he laughed
and shook his
fat sides,
To think his niece
would be a bride, M-hm.
Uncle Rat went a-running
down to town,
To buy his niece
a wedding gown, M-hm.
"Where shall the wedding
supper be?"
"Way down yonder in
the hollow tree," M-hm.
"What shall the wedding
supper be?"
"A fried mosquito and
a black-eyed pea,"
M-hm.

Calendar
Here is a paper collage featured in a calendar
for Children's Hospital in Washington, DC.

Magazine Ad

This ad is one of a number of all-paper collages prepared for Pepsi advertisements. The playful nature of this piece is similar to some of the collages appearing elsewhere in this book.

Poster

This National Geographic Society poster has papers and engravings overlaid on a silver foil background.

Book Review

Done for *Outlook Review*, this collage contains pen engravings, cutout letters, black paper, ink spatters and splotches of white paint.

More Ideas for Realistic Collage

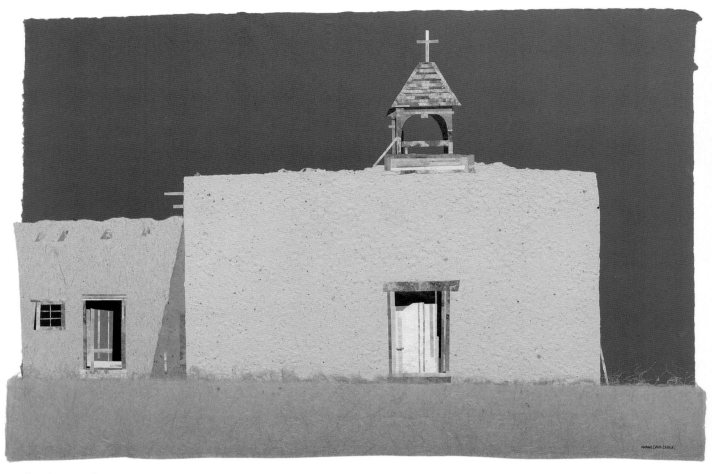

A church in northern New Mexico.

NIGHT PASSAGE
30"×40" (76.2cm×101.6cm)

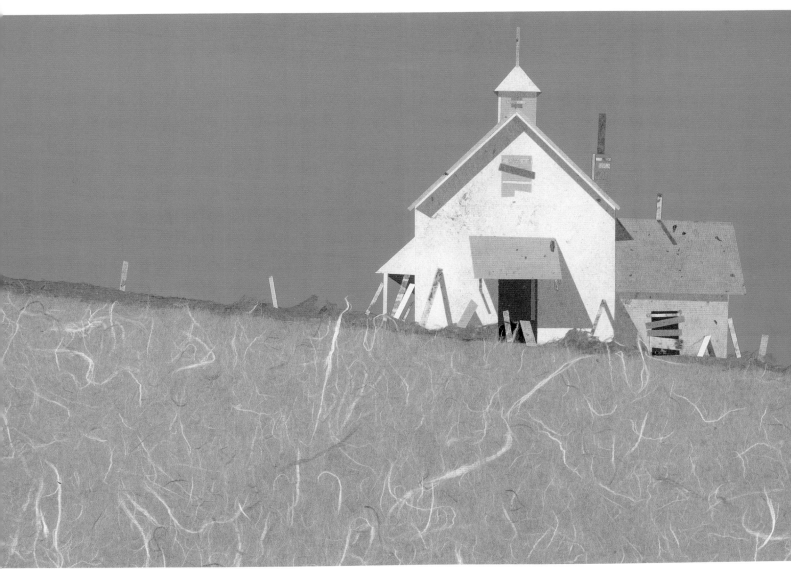

A schoolhouse on an intensely bright day.

THE OLD SCHOOLHOUSE
8½" × 11" (21.6cm × 27.9cm)

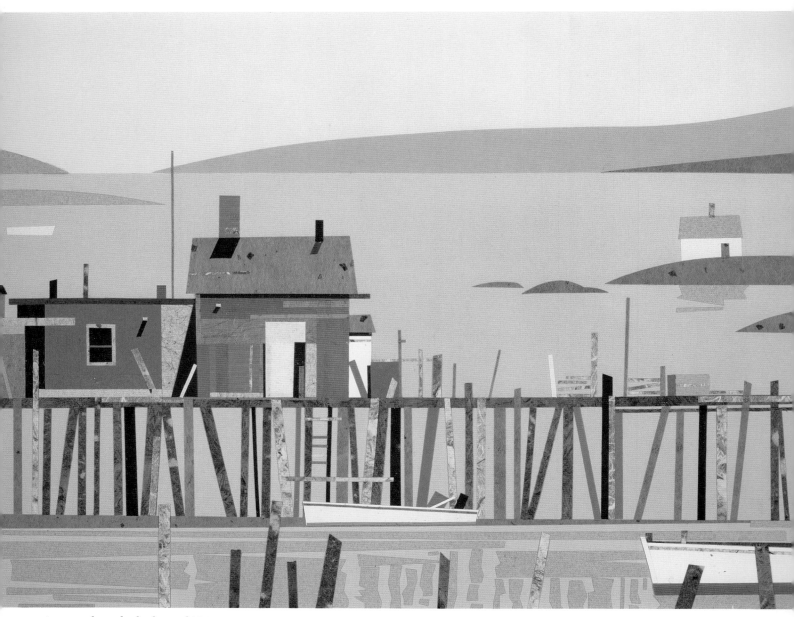

A scene along the harbors of Maine.

MORNING FOG
11¾" × 15½" (29.9cm × 39.4cm)

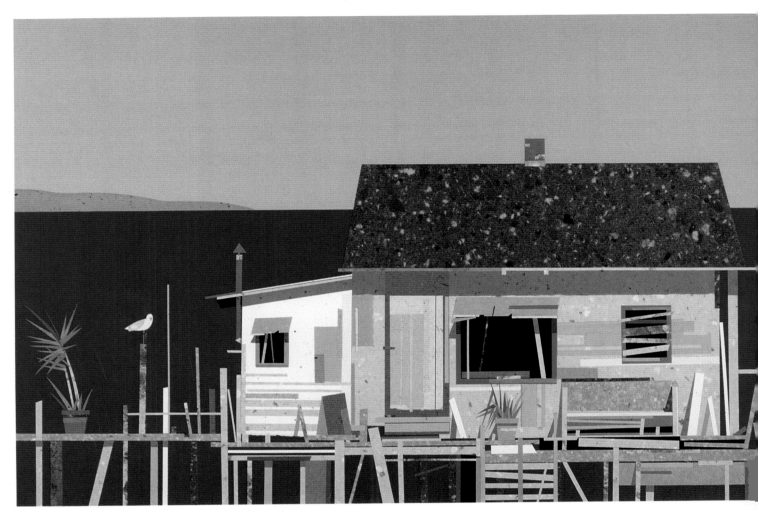

A lazy, sun-drenched day by the sea.

KEY WEST
30" × 40" (76.2cm × 101.6cm)

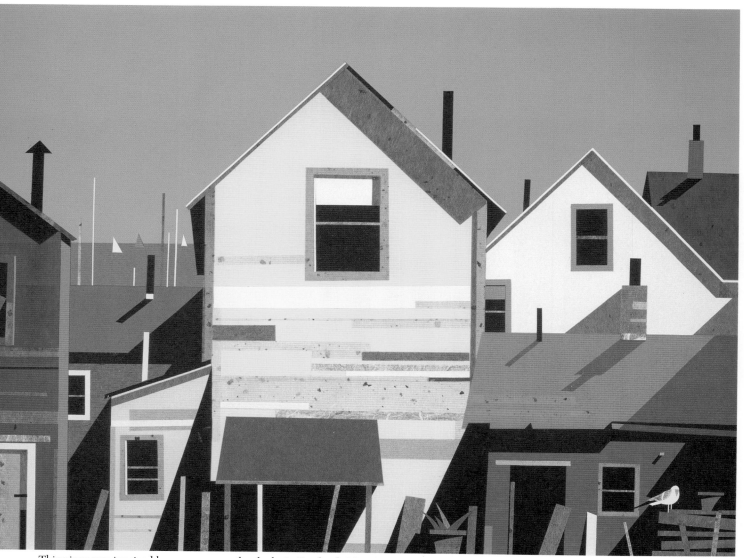

This piece was inspired by a scene near the docks in Portland, Maine.

BACK STREET
8½″×11″ (21.6cm×27.9cm)

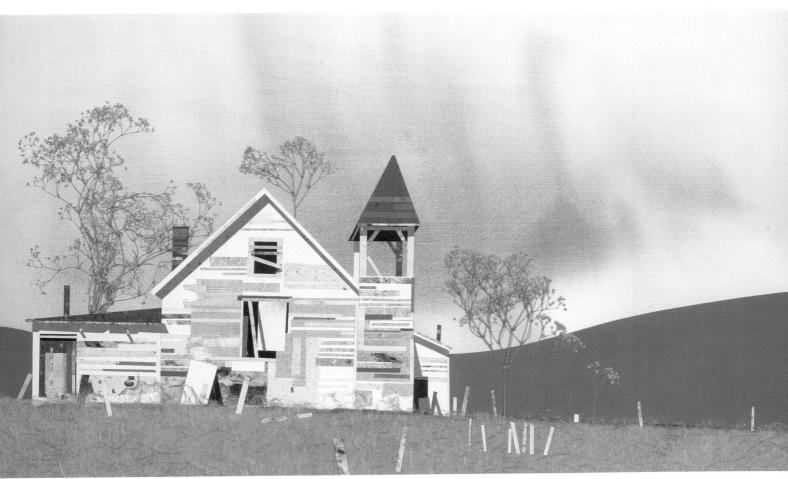

An abandoned schoolhouse near Castine, Maine.

IMPENDING STORM
17″ × 29″ (43.2cm × 73.7cm)

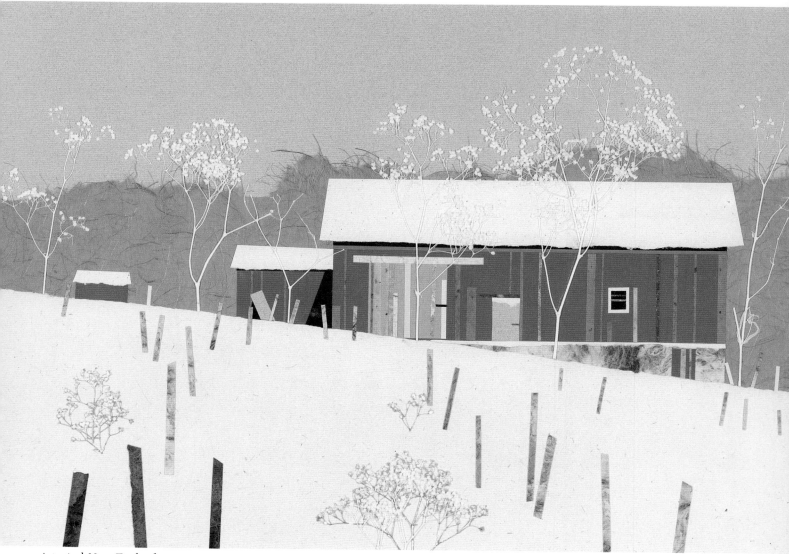

A typical New England snow scene.

FRESH SNOW
13½″ × 19½″ (34.3cm × 49.5cm)

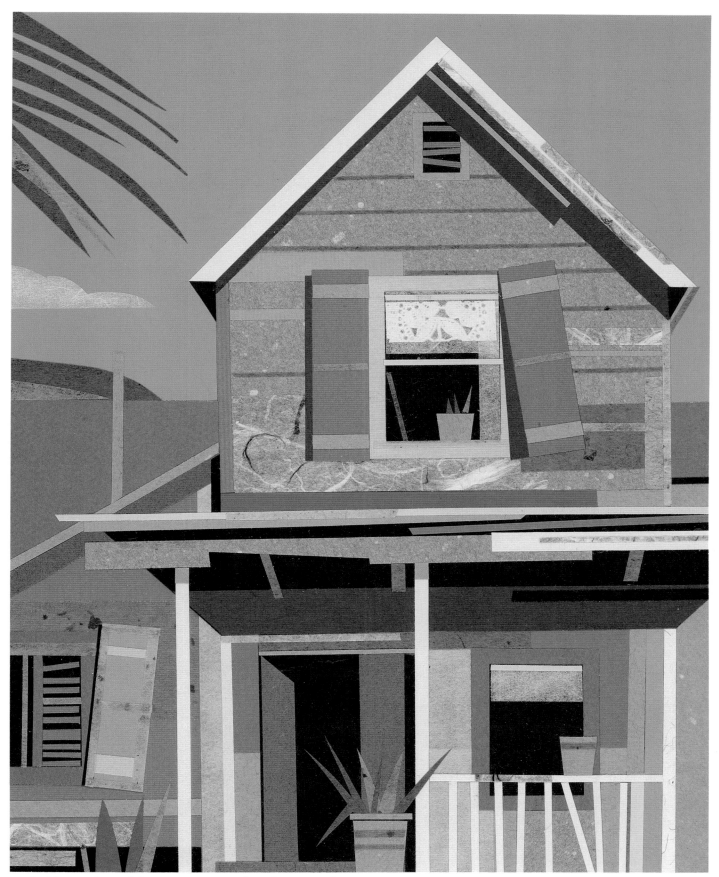

A colorful scene done while on a trip to Grenada in the West Indies.

JUST ANOTHER DAY
8½″×11″ (21.6cm×27.9cm)

STILL LIFE WITH JUG, FRUIT AND CHEESE BOARD
Robert Kilvert
30″ × 25″ (76.2cm × 63.5cm)

ROBERT KILVERT
Weobley, England

Kilvert usually builds his intriguing collages from the pages of the glossy weekly color supplements that come with the newspapers. Sometimes he uses the glossy pages from magazines, but he seldom mixes the two. His approach to building a collage is intriguing. He doesn't cut out pieces similar to what he is trying to depict—for example, he does not use a picture of hair to represent hair or a picture of an apple to represent an apple in his collages. Instead, he looks for the colors and textures he needs and builds his objects using those cuttings, as a painter might use strokes of paint. Kilvert finds he does not work well surrounded by a mass of scraps and cuttings, so he doesn't save many of them for future collages, preferring to start fresh with new color supplements.

He is careful to use pH-neutral adhesives and support materials, but he warns that the collage will fade if not protected by glass or Plexiglas that filters out ultraviolet light.

chapter five
Gallery 2

GUEST COLLAGE ARTISTS

Here is a sampling of artists whose work may loosely be considered collages. As you'll see, there are no limits on the subjects for collages, nor on the materials and techniques used. The collage tent is large and accommodating.

PEGGY BROWN
Nashville, Indiana

This artist often combines watercolor, graphite pencil and charcoal. Here she paints the background first on Rives printing paper using delicate watercolor tints and sifts some powdery charcoal into the wet paint. When the paper is dry, she brushes away any loose charcoal. She paints strips of paper, cuts or tears them into shapes she likes, and tries them in various positions on the background sheet. Later she adds texture by drawing with graphite pencils.

ANOTHER FORM II
Peggy Brown
26″ × 19″ (66.0cm × 48.3cm)

CROSSCURRENTS II
Peggy Brown
$26'' \times 36''$ *(66.0cm × 91.4cm)*

Brown cuts a painted rectangle into two pieces whose proportions she likes. She shifts the pieces relative to one another before fastening them in place. In addition to her usual watercolor, graphite pencil and powdered charcoal, she uses water-soluble white pencils across the horizontal center area.

Design is always first on Peggy Brown's list of priorities. Next comes texture and then color. Brown doesn't fasten anything permanently until she's satisfied with her design. Then she uses dots of a pH-neutral adhesive called Lineco to fasten pieces in place. She purposely does not glue most pieces tightly to the background because she likes the loose, three-dimensional effect of slightly lifted or curled edges. She frames her collages under glass. Along with her husband, Jim, a prizewinning photographer, she exhibits and sells her work at art fairs around the country.

WILLIAM AND LaTRECE COOMBS

Conyers, Georgia

This husband-and-wife team uses a great variety of materials to make rather formal assemblages. In this one, they used rag mat board, crumpled tissue paper, paint (some laid on using conventional means and some airbrushed), a piece of etched magnesium, a fragment of a fluorescent light diffuser, perforated aluminum, Plexiglas rods, electronic circuit board components, metal O-rings and thin sheets of clear acrylic. Lighter elements in these pieces are glued on, but heavier pieces are secured with brass wire.

INCEPTION I
William and LaTrece Coombs
28″×18″ (71.1cm×45.7cm)

SOUTH WIND
William and LaTrece Coombs
22″×28″ (55.9cm×71.1cm)

As in *Inception I*, there are many metallic and plastic components here. The background is a sheet of handmade marbleized paper. (For a discussion of marbling, see North Light's *Creative Collage Techniques* by Leland and Williams.)

In their early constructions, the Coombs team used mostly "found" objects—things that were at hand and usually free. They soon found it necessary to broaden their stock of materials by buying items, such as Plexiglas rods, not generally found lying around. Since William Coombs has a varied background that includes printmaking and acrylic and oil painting, his experience comes into play in these constructions. Often the artists use a material they have etched or embossed; sometimes there will be a small section of clear plastic with a scene or some abstract design painted in oil or acrylic. Frequently, elements are airbrushed. There is no material or technique off-limits to these assemblages.

PHIL METZGER

Rockville, Maryland

ANOTHER WORLD
Phil Metzger
30" × 40" (76.2cm × 101.6cm)

This is a combination of acrylic paint and torn papers. The support is ¼" (.6cm) hardboard with several coats of acrylic gesso. I first poured fluid blue-black acrylic paint over the entire board except for the masked-off edges that would later be covered by a mat. While the dark paint was still wet, I flung a few blobs of white acrylic paint into it. I let it dry then used layers of several types of papers to complete the image. Some are thin, white, fibered papers that allow the underlying paint color to show through. Others are a paper called *Unryu* which I first tinted with acrylic paint and, when dry, tore and glued down using acrylic gloss medium. Some of the whiter, opaque pieces are a smooth paper similar to bond typing paper. The red circle is painted paper and the red line across the lower area is acrylic paint.

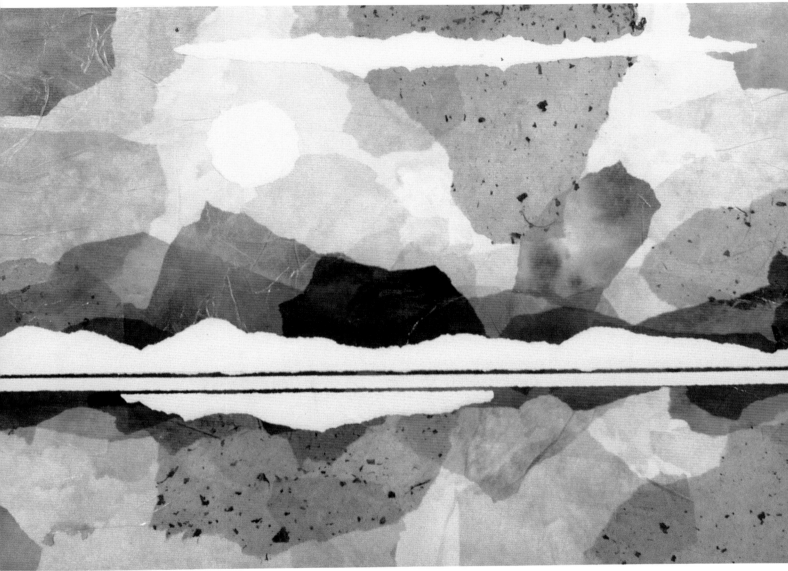

The only paint in this collage is that used to tint a few of the papers before gluing them down. The opaque, white horizontal strips are pieces of torn 140-lb. (300g/m²) watercolor paper.

Like *Another World*, this collage was done on ¼" (.6cm) hardboard. Once matted and framed under glass, both these pictures weighed a ton! Better choices would have been rag mat board, illustration board, watercolor board or foamboard.

UNTITLED
Phil Metzger
30" × 40" (76.2cm × 101.6cm)

119

SHIRLEY PORTER

Rockville, Maryland

FOSSIL
Shirley Porter
30" × 40" (76.2cm × 101.6cm)

Working on an illustration board support, Porter uses a combination of acrylic paint and gold and silver metallic leafing to form an abstract background. Once the background is textured and colored to her satisfaction, she begins forming the representational image she has in mind using the same combination of materials as in the background. She builds up the image layers until she's satisfied with the balance between abstraction and realism. Many shapes are defined by using negative painting—that is, painting the area around an object. For instance, a fin might begin as a formless area of leafing; it takes shape as a fin only when darker acrylic paint is used as background.

BUGGED
Shirley Porter
24" × 30" (61.0cm × 76.2cm)

This is another collage using metallic leafing and acrylic paint, built up in the same manner as *Fossil*. In this case, the light wings look as though they were made using a translucent paper, such as a rice paper, but in fact they were painted with thinned acrylic paint.

The metallic leafing Porter uses is not true gold or silver. Instead she uses *composition leaf*. Composition gold leaf is made of brass and composition silver leaf is made of aluminum. These are, of course, much less expensive than gold and silver leaf.

VIRGINIA LEE WILLIAMS

Trotwood, Ohio

Virginia Lee is an experimenter. Her collages reveal a wide range of subjects, ideas and materials. She often begins a collage by preparing sheets of paper with acrylic color before having a subject in mind. She spends considerable time looking at the sheets, walking around them, shuffling them until the germ of an idea forms. Then she begins cutting and tearing the prepared sheets and placing them tentatively on a support. She eventually adheres pieces using acrylic matte medium. As a collage takes shape, Virginia Lee does a lot of additional painting with regular acrylic paint and occasionally the metallic and interference varieties as well.

To prepare papers for this collage she poured acrylic paint onto 140-lb. (300g/m²) watercolor paper and laid various objects into the still-wet paint, removing the objects when the paint was nearly dry. After the papers were dry, she used some of those same objects again, coating them with paint and pressing them against the paper.

THE SHAMAN SYMBOLS I
Virginia Lee Williams
28″×24″ (71.1cm×61.0cm)

122

NITA LELAND AND VIRGINIA LEE WILLIAMS

Dayton, Ohio *Trottwood, Ohio*

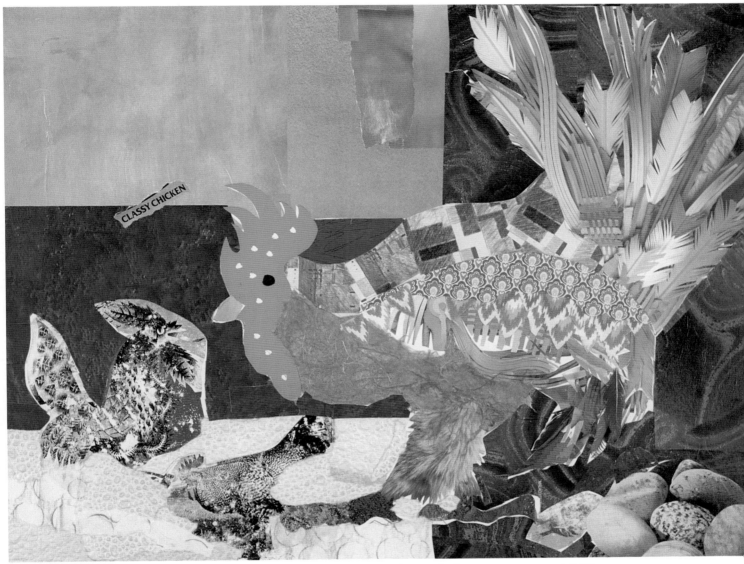

CLASSY CHICKEN
Nita Leland and Virginia Lee Williams
15" × 20" (38.2cm × 50.8cm)

Virginia Lee collaborated with her friend Nita Leland on this piece. They include a step-by-step demonstration of the making of this collage in their excellent North Light book *Creative Collage Techniques*. The finished collage graces the cover of their book.

For *Classy Chicken*, the artists used a variety of materials including cuttings from magazines, pieces of wallpaper and heavily fibered rice paper. They began with a careful drawing of the large chicken and then began cutting and trying pieces, making sure they were satisfied with colors, textures and placement before finally adhering the pieces with acrylic medium. They left the background relatively simple to avoid conflict with the chicken, which was to be quite busy. One unusual technique they employed is the transferring of an inked image from a magazine page to the collage support. Rather than cutting out the magazine picture and pasting it onto the collage, they transferred only the ink from the magazine page (the two smaller chickens were done in this way). This transfer technique is described in detail in their book.

SOURCES FOR COLLAGE TOOLS AND MATERIALS

Any large art supply store or catalog should offer a good range of papers, paints and adhesives. Craft supply stores are a gold mine of odds and ends that may be just what you need for your collage, and don't forget hardware stores, grocery stores and plastics suppliers. In addition, flea markets and yard sales can be good sources for offbeat items. Some art supply stores and catalogs and some of the larger photographic supply stores carry dry-mount presses and dry-mount supplies. Here are a few specific suppliers you might try:

Art Express
P.O. Box 21662
Columbia, SC 29221
(800) 535-5908

Carriage House Handmade Paperworks
1 Fitchburg St. C207
Somerville, MA 02143

Catherine's Rare Papers
7064 E. First Ave., Ste. 103-104
Scottsdale, AZ 85251

Charrette
P.O. Box 4010
Woburn, MA 01888
(800) 367-3729

Daniel Smith Artists' Materials
4150 First Ave. S.
P.O. Box 84268
Seattle, WA 98124-5568
(800) 426-6740

Dick Blick Art Materials
P.O. Box 1267
Galesburg, IL 61402-1267
(800) 828-4548

Jerry's Artarama
P.O. Box 1105J
New Hyde Park, NY 11040
(800) 827-8478

New York Central Art Supply
62 Third Ave.
New York, NY 10003
(800) 950-6111

Papersource
232 W. Chicago
Chicago, IL 60610
(312) 337-0798

Pearl Fine Arts
308 Canal St.
New York, NY 10013
(800) 451-7327

Twinrocker Handmade Paper
P.O. Box 413
Brookston, IN 47923

Vicki Chober Co., Inc.
2363 N. Mayfair Rd.
Milwaukee, WI 53226

Washington Mouldings
11015 West Ave.
Kensington, MD 20895
(301) 946-7311

BIBLIOGRAPHY

Betts, Edward. *Master Class in Watermedia*. New York: Watson-Guptill, 1993. Thorough and beautifully illustrated coverage of watermedia, including collage with watermedia.

Brown, Michael David. *Washington D.C.* Rockville, MD: Winterberry Publishing, 1994.

Brown, Michael David. *Viewpoints.* Rockville, MD: Winterberry Publishing, 1994.

Brommer, Gerald. *Watercolor and Collage Workshop.* New York: Watson-Guptill, 1986.

Leland, Nita and Virginia Lee Williams. *Creative Collage Techniques.* Cincinnati: North Light Books, 1994. Thorough treatment of materials and techniques used in collage, including dozens of practice projects.

Metzger, Phil. *Enliven Your Paintings With Light.* Cincinnati: North Light Books, 1993. How light behaves; painting shadows and reflections.

Metzger, Phil. *The North Light Artist's Guide to Materials and Techniques.* Cincinnati: North Light Books, 1996. The materials and techniques you need to get started in all popular mediums.

Metzger, Phil. *Perspective Without Pain.* Cincinnati: North Light Books, 1992. All aspects of perspective: one-point, two-point, three-point, overlap, size variation, edges, etc.

ART CONTRIBUTORS TO THIS BOOK

All art used by permission.

Michael David Brown
235 Old County Rd.
Rockport, ME 04856

Peggy Brown
1541 N. Clay Lick Rd.
Nashville, IN 47448

William and LaTrece Coombs
1130 Haynes Creek Dr.
Conyers, GA 30207

Robert Kilvert
The Old Corner House
Weobley, Hereford
England, HR4 8SA

Nita Leland
1210 Brittany Hills Dr.
Dayton, OH 45459

Phil Metzger
14315 Woodcrest Dr.
Rockville, MD 20853

Shirley Porter
14315 Woodcrest Dr.
Rockville, MD 20853

Virginia Lee Williams
329 Carthage Place
Trotwood, OH 45426

INDEX